A–Z
OF
LEITH
PLACES - PEOPLE - HISTORY

Lisa Sibbald

AMBERLEY

About the Author

Lisa Sibbald has lived in Edinburgh her entire life and has always had a great love for the city and its history. She is a reviewer of books, theatre, music, ballet and opera, and also writes articles and features. Lisa's first book, *A–Z of Edinburgh*, was published in January 2018, and she is delighted to have been able to follow this up with *A–Z of Leith*.

Unless otherwise acknowledged, all photographs are © Lisa Sibbald 2018.

www.lisasibbald.weebly.com

First published 2018

Amberley Publishing
The Hill, Stroud, Gloucestershire, GL5 4EP
www.amberley-books.com

Copyright © Lisa Sibbald, 2018

The right of Lisa Sibbald to be identified as the Author of this work has been asserted in accordance with the Copyrights, Designs and Patents Act 1988.

ISBN 978 1 4456 8205 1 (print)
ISBN 978 1 4456 8206 8 (ebook)

All rights reserved. No part of this book may be reprinted or reproduced or utilised in any form or by any electronic, mechanical or other means, now known or hereafter invented, including photocopying and recording, or in any information storage or retrieval system, without the permission in writing from the Publishers.

British Library Cataloguing in Publication Data.
A catalogue record for this book is available from the British Library.

Origination by Amberley Publishing.
Printed in Great Britain.

Contents

Introduction	4	King's Landing	35	Signal Tower	76
		King's Wark	36	Smith & Bowman	77
Air Raids	5	Kirkgate	37	South Leith	
Amalgamation	6			Parish Church	79
		Lamb's House	39	State Cinema	81
Baltic Street	7	Dr Thomas Latta	40	Sunshine on Leith	82
Dr Bell's School	7	Leith Airport	41		
Boothacre Cottages	8	Leith Bank	41	Timber Bush	83
Boundary Bar	8	Leith Central Station	42	Trinity House	83
Eric Melrose Brown	9	Leith Citadel	43		
Burntisland		Leith Fort	46	Urban Regeneration	85
Harbour Light	10	Leith Hospital	47		
		Leith Links	50	The Vaults	88
Cables Wynd House	11	Leith Theatre	52	Victoria Swing Bridge	89
Corn Exchange	12	Leith Walk	53		
Crabbie's	13			Irvine Welsh	91
Crawford's Biscuits	14	Martello Tower	55	Whisky Bonds	91
Custom House	15	Merchant Navy			
		Memorial	56	X-rated	93
Dalmeny Street		Mural	57		
Drill Hall	16			Yuletide Card	94
Darien Scheme	17	North Leith			
Docks	18	Churchyard	58	Zeppelin Air Raid	95
		North Leith			
Eldorado	20	Parish Church	59	Acknowledgements	96
J. D. Fergusson	21	Ocean Terminal	61	Bibliography	96
Firemarks	21	Dean Owens	62		
Foot of the Walk	22				
		Persevere	63		
Dick Gaughan	24	Pilrig	64		
Gibson's Aeroplanes	24	Plague	66		
Glassmaking	25				
Glayva	26	The Quilts	67		
Gretna Rail Disaster	26				
		Rose's Lime Juice	68		
Henderson Street	29	Royal Yacht *Britannia*	68		
Governor John Hunter	30				
		Sailors' Home	70		
International		St Ninian's Manse	72		
Community	32	Christian Salvesen &			
		Co.	73		
Junction Bridge	34	Shipbuilding	75		

Introduction

Leith has been part of the city of Edinburgh since 1920, but retains a very definite identity of its own. It has an ancient history as a port, which has shaped its buildings and people for many centuries. At various times it has been invaded, razed to the ground and bombed, but Leithers have always lived up to their motto 'Persevere', and rebuilt their homes, businesses and lives.

Over the last few decades there have been many changes to Leith, with old buildings being demolished and new ones built, traditional businesses closing and new ones taking their place, but through it all Leith remains a very individual and vibrant area.

Malmaison Hotel, formerly Sailors' Home. (Copyright reserved Leith Walking Tours, tour guide and artist Graeme McCormack)

A

Air Raids

Leith suffered a considerable amount of fatalities, injuries and damage to property during the Second World War.

The *Scotsman* newspaper reported that on 18 July 1940, during the first air raid of the war on Edinburgh,

> One of the bombs that evening hit a tenement in George Street, Leith, causing several fatal casualties, and seriously damaging the property. Some of the residents had remarkable escapes. As there had been no warning, shelters were unoccupied, and it was tragically ironic that a girl who had gone into a backgreen shelter was killed by a bomb which secured a direct hit.

George Street was demolished after the war and the street name itself disappeared, becoming part of North Fort Street to avoid confusion with George Street in the New Town. Another of the bombs exploded a few hundred metres away on the tramline in Portland Place. Although a tramcar was not far off with around twenty passengers on board, and the blast blew the glass out of the windows, no one was injured.

The next major event was on 7 April 1941 when the tremendous power of a mine shattered a roof at Leith Town Hall (now Leith Library). The infant annexe of David Kilpatrick School next door was demolished and a church hall badly damaged. Several residents in Largo Place, near Leith Hospital, were killed when a bomb hit tenements there. Three churches and as many as 200 shops and 270 houses were also damaged in the raid, in which two landmines had been dropped by parachute. One of the tenements in Largo Place had to be partly demolished due to the damage. Apparently Leith hadn't even been the target on this occasion; the German aircraft had been heading for the Clydebank shipyards when they were intercepted by RAF fighters. The German bombers unloaded their bombs to facilitate a quick getaway and these unfortunately just happened to fall upon Leith.

Junction Bridge Station and Largo Place, 8 April 1941. (© J. L. Stevenson. Reproduced by kind permission of Hamish Stevenson and Kenneth Williamson)

Amalgamation

Until 1833, Leith was controlled by Edinburgh town council, who were the feudal superior of the land. However, in 1833 Leith became an independent burgh, a state which continued until 1920 when Leith officially became part of Edinburgh. By that time Edinburgh had already acquired Seafield on one side and Granton on the other, so Leith was the only place standing in the way of Edinburgh having the entire area. In 1919, Edinburgh was seeking a Boundaries Extension Act, which would allow the city to take over Leith.

 A plebiscite (referendum) was to be held, and the town clerk of Leith had printed voting forms to be sent out to every address in Leith, a total of some 39,000 forms. By the deadline for return, almost 31,000 forms had been returned. However, despite an overwhelming majority voting for continued independence for Leith, the amalgamation went through. This decision angered many Leithers, and was remembered with great resentment for a long time. However, despite being officially part of Edinburgh, Leith has always maintained its own distinct identity and its people remain very firmly Leithers.

B

Baltic Street

Baltic Street first appears on a 1753 map, giving direct access from the Shore to the coast road to Musselburgh, as well as to the first of the glass furnaces, which had recently been set up on South Leith Sands.

While the name may refer to Leith's trading connections, as do Elbe Street, Madeira Street and Cadiz Street, it is more likely that it specifically refers to a corn exchange, as 'The Baltic' was then the usual name for the London corn exchange.

It may not have been entirely coincidence that when Leith's new corn exchange was built in 1869 it was sited in Baltic Street.

Dr Bell's School

Andrew Bell was born in 1753 in St Andrews, Fife. He was educated at St Andrews University, then emigrated to America at the age of twenty-one. From 1774 to 1781 he was tutor to the children of plantation owners in Virginia, then subsequently returned to Scotland, deciding then to enter the church.

From 1784 to 1787 Andrew Bell lived in Leith, after which he went to India in the service of the East India Company, where he worked for the church but was mostly involved in the Madras Orphanage for sons of soldiers. Finding it impossible to get trained teachers, he resorted to running the school by teaching the brighter or older children and then allowing them to teach the younger ones. The pupils who assisted the teacher were called monitors, and the teaching method became known as the 'Madras System'. Bell disapproved of corporal punishment and preferred to use a system of rewards for good behaviour rather than punishment for bad behaviour.

After returning to Britain in 1797 because of ill health, Dr Bell published his report called 'An Experiment in Education made at the Male Asylum of Madras', and from 1798 the system began to be introduced into several English schools. Within his lifetime, his system was in use in over 12,000 schools. Dr Bell founded several schools including one in Leith.

The former Dr Bell's School, Great Junction Street.

Dr Bell died in 1832 and was buried in Westminster Abbey. He left the then large sum of £120,000, of which £10,000 was bequeathed to Leith.

The present building in Great Junction Street was erected in 1838, and acquired by Leith School Board and reconstructed by them in 1892. A niche on the front of the building holds a statue of Dr Bell holding an open book in his hands.

The building is no longer used as a school and now houses Dr Bell's Family Centre, a children's nursery, and private flats.

Boothacre Cottages

At the east end of Leith Links, the names of Boothacre Cottages and Boothacre Lane are a reminder of the great plague of 1645. Wooden ludges or booths were built on Leith Links so that victims of the plague could be isolated and, from this, the area of ground would have become known as the boothacre.

Boundary Bar

The Boundary Bar in Leith Walk was situated on the border between Leith and Edinburgh, when they were still separate and had different licensing laws. The Bar had two entrance doors, one in Leith and one in Edinburgh, and a metal marker on the floor indicated the boundary between the two parts.

When last orders was called in Edinburgh, the customers could move over to the Leith side of the bar and enjoy another half hour's drinking. This unusual state of affairs remained in force until Leith and Edinburgh amalgamated in 1920.

Boundary Bar in a recent reincarnation. (© fawkes-that.com (Brian McNeil) 2017)

In the 1960s, Edinburgh and Leith still had separate licensing authorities, and the Leith licensing authority allowed the bar to open at 5 a.m. to cater for dockers, railway staff and bond warehouse workers when they had finished working a night shift. However, the Edinburgh licensing authority didn't agree with this, so drinkers had to remain at the Leith end of the bar for their early morning refreshments.

In 2002, the Boundary Bar's name was changed to the still appropriate City Limits. However, further changes of ownership and management, with consequent name changes, have meant that the history of this pub is in danger of being forgotten.

Eric Melrose Brown

Born in Leith on 21 January 1919, Eric Brown went on to become the most decorated pilot in the history of the Royal Navy.

Brown, nicknamed 'Winkle' because of his short stature, flew 487 types of aircraft in his career as a Royal Navy officer and test pilot, more than anyone else in history. He holds the world record for the most aircraft carrier deck take-offs and landings (2,407 and 2,271 respectively) and achieved a number of firsts in naval aviation.

Brown's first formal flying instruction was while he was a student in modern languages at the University of Edinburgh, where he was a member of the university's

air unit. He was an exchange student in Germany in September 1939 when war broke out, and on returning to the United Kingdom he joined the Royal Navy Volunteer Reserve as a Fleet Air Arm pilot.

During his service on board HMS *Audacity* during the Second World War, the ship was torpedoed and sunk. Brown was in the freezing cold sea overnight, and was the only survivor.

Brown received many honours and awards during his illustrious career with the Royal Navy. He retired in 1970, but continued flying until 1994 and was still lecturing in 2015. He died on 21 February 2016 at the age of ninety-seven after a short illness. In July 2018, a life-size bronze statue of Brown was unveiled at Edinburgh Airport.

Burntisland Harbour Light

The light tower situated close to Tower Place in Leith, although it may look as though it belongs there, was originally the Burntisland Harbour East Breakwater Light, built in 1876 and active until around 1954. It comprises a 7-metre-high octagonal tower with lantern and gallery, and was moved from Burntisland in Fife to its current site in Leith around 1990, presumably as a piece of 'maritime decoration' when the area was being revitalised.

Burntisland Harbour Light, now at the Shore.

C

Cables Wynd House

It is likely that the street known as Cables Wynd was named for Henry Capell, or Capill, maltman and brewer in Leith who was made a free maltster in 1660.

Nowadays it is best known as the site of Cables Wynd House, popularly known as the Banana Flats because of its curved shape. Cables Wynd House is a nine-storey council housing block. Oddly though, the building itself actually has ten storeys, with the ground floor rather confusingly being called Cables Wynd and the upper nine floors being Cables Wynd House.

Cables Wynd House – better known as the Banana Flats.

At the time of building, it was the largest block of flats in Edinburgh, containing over 200 flats. The building was first occupied in 1962 and for many of its original tenants it was a welcome improvement over the poor housing conditions and overcrowding that were common problems at the time. When they were first built, the flats were revolutionary, with innovations such as underfloor heating, lifts and a concierge.

In the 1980s, Cables Wynd House unfortunately gained a reputation for being a heaven for drug users and dealers, and was featured in Irvine Welsh's *Trainspotting* as the location of a drug den. In contrast to this, however, many residents of Cables Wynd House recall it being a friendly place to live, with plenty of community spirit and people taking pride in their surroundings.

In a surprise move by Historic Environment Scotland in February 2017, the flats were given Category A listing, meaning that they are of national or international importance.

Corn Exchange

The Corn Exchange, on the corner of Constitution Street and Baltic Street, was built in 1861 as an open marketing hall at a cost of £7,000. It originally had a hall 31.5 metres long by 21 metres broad, and an octagonal tower at the corner.

An outstanding feature of the building is the frieze sculpted by John Rhind, which runs for around 23 metres along the side of the building down Constitution Street, depicting cherubs taking part in the processes of bringing the grain to Leith, such as sowing, harvesting and transporting.

Detail of the frieze along the side of the Corn Exchange.

The Corn Exchange on the corner of Baltic Street and Constitution Street.

In 2013, after conversion, with funding from the City of Edinburgh Council, Creative Scotland and Edinburgh College, the building reopened as the Creative Exchange, some 740 square metres of open-plan workspace for people working in creative industries.

Crabbie's

Crabbie's dates back to 1801 when Miller Crabbie was a merchant in Edinburgh. The business was inherited by his son John Crabbie, who went on to found John Crabbie & Co. In the mid-nineteenth century John Crabbie acquired a former porter brewery located between Yardheads and Great Junction Street in Leith, and over the years the premises were extended mainly to provide bonded warehouses for Crabbie's whisky business. The company was also engaged in gin rectifying and the production of fruit-based cordials. Of these, Crabbie's was best known for its green ginger wine, which continued to be made in Leith until the 1980s when John Crabbie & Co. was taken over by another Leith distiller and blender, Macdonald & Muir, and production of green ginger wine was transferred to West Lothian.

Crawford's Biscuits

Crawford's biscuits originated in Leith, when ships' biscuits were produced in a small shop on the Shore in 1813. Mr Mathie took over the business in 1817, and in 1856 William Crawford succeeded him. Crawford was a master baker who quickly expanded the business and by 1879 had established a custom-built factory in Elbe Street. The company grew when William Crawford decided to send two of his sons off to Australia in 1897 to establish a subsidiary. They got as far as Liverpool, from where they were to set sail, and decided instead to establish a factory there. By the 1920s, William Crawford & Sons employed hundreds of people at their factories in Leith and Liverpool. The girls who worked in Crawford's factory in Elbe Street were known as 'white mice' due to the white overalls they wore.

A new factory was built in Anderson Place in Leith in 1947, and it served as a warehouse and production space for several years. After its closure it fell into disrepair, but in 2015 was transformed into the aptly named 'The Biscuit Factory', a creative events space with studios and offices.

Douglas Inglis Crawford, born in 1905, was the company chairman by 1956, when the company was still privately owned and largely in the hands of the Crawford family.

In 1962, William Crawford & Sons was sold to United Biscuits for £6.25 million, and the Leith factory closed in 1970, with the loss of over 700 jobs.

D. S. Crawford, the popular Scottish bakery chain, was a subsidiary company, which was subject to a management buyout in 1990.

December 1955 magazine advertisement for Crawford's Tartan Shortbread.

Custom House

The Custom House, situated on the Shore at Commercial Street, was built in 1812 at a cost of £12,617 for the collection of duties on goods passing through the Port of Leith. It is a grand building in the neoclassical Greek Doric style, with a central recessed portico. Its use as a custom house ceased in 1980 and after that it was mainly used as a store by the National Museums of Scotland for many years. However, in 2014 the building was purchased by the City of Edinburgh Council, who are now leasing it to Scottish Historic Buildings Trust, a charity whose remit is to bring unused historic buildings back to life. The building is now back in use for various creative purposes, with an art school, exhibitions, workshops and performances using the building. Scottish Historic Buildings Trust have secured funding for a feasibility study to look at the capital works needed to keep the building sustainable and to restore and conserve its historic fabric, and to consider its future use. There was a local campaign for the former Custom House to become a Leith Museum, and Scottish Historic Buildings Trust have said they intend to give over part of the building for this purpose, although as yet nothing definite has been proposed.

Custom House, Commercial Street.

D

Dalmeny Street Drill Hall

This Category A-listed building was constructed in 1901 as a military drill hall at a cost of around £13,000. It was designed by the firm of Anderson, Simon and Crawford in the neo-baroque style, as the headquarters of the 5th Volunteer Battalion Royal Scots (Lothian Regiment), who evolved to become the 7th (Leith) Battalion, The Royal Scots, in 1908. This was of course the regiment that lost many of its men in the Gretna

Dalmeny Street Drill Hall – now 'Out of the Blue'.

rail disaster of 1915, and the drill hall was used as a temporary mortuary when the bodies were brought home to Leith.

The building is of significance because of the high quality of the design, whereas most drill halls were fairly modest and utilitarian, and is one of the largest and best detailed examples of a drill hall in Scotland. Its original purpose was as a space to train and drill volunteer soldiers as well as somewhere for the secure storage of weapons, with accommodation space for a caretaker or drill instructor.

Through several amalgamations and name changes of the battalions, the building continued to be used as a drill hall until 1999, when the battalion that had been based there moved to the East Claremont Street Drill Hall, and the building was decommissioned. In 2003 it was sold to the arts charity, Out of the Blue, and restored and reconstructed in 2004 for use as an arts and education centre, with artists' studios, a café, gallery and rehearsal and performance spaces, as well as a popular monthly flea market.

Darien Scheme

At the end of the seventeenth century Scotland was in a state of crisis. Wars, famine, and problems with trade and industries meant that the country was struggling financially. William Paterson, a Scotsman who had been one of the founding directors of the Bank of England, had heard positive reports of Darien on the Isthmus of Panama, and believed he could locate a lucrative trading colony there, which could turn Scotland's fortunes around.

In 1695 King William sanctioned the setting up of the 'Company of Scotland Trading to Africa and the Indies'. The intention of this company was to found a colony to be called New Caledonia in Darien. The mention of Africa and the Indies in the company's name attracted the hostility of the East India Company, which threw its political and financial weight into efforts to defeat the Scots' plans. In June 1696 Alexander Stevenson, merchant burgess and skipper of Edinburgh, and James Gibson, his counterpart in Glasgow, were commissioned to buy and have built ships for the expedition. Four ships of 350 tons, carrying fifty-six guns, were built at Hamburg in Germany. In March 1697, two of them, the *Caledonia* and the *Installation* (renamed the *St Andrew*), were launched. The other two were launched a month later, but remained in Hamburg until the following year. At the same time a further two, the *Rising Sun* and the *Unicorn*, were being built in Amsterdam.

In July 1698 the *Endeavour* (which had been bought in England) sailed from Leith along with *Caledonia*, *St Andrew* and *Unicorn*, with a total of 1,200 settlers on board, arriving at the Darien Isthmus in November of that year. In September 1699 five more ships left for Darien from the Clyde. However, they did not know that the first expedition had failed, largely due to disease and lack of supplies. The latter was blamed on the English policy of refusing to sell necessities to the Scottish settlers – a policy that had been forced on King William.

On 11 November 1699, *Caledonia* arrived home in Scotland, in the Sound of Isla, with just 200 survivors. *Endeavour* had been lost, *Unicorn* was badly damaged and *St Andrew* had been left behind at Darien. A second expedition established itself at Darien, but came under attack by the Spaniards and was forced to capitulate in March 1700.

The company continued to send one or two ships a year to Africa and India, but it was never a commercial success, and the loss of capital through the Darien disaster was a major factor in the economic weakening of Scotland, which was to lead to political union with England in 1707.

The Darien Chest, which was used to hold cash and documents associated with the Company of Scotland, can be seen in the National Museum of Scotland, Chambers Street, Edinburgh.

Docks

Leith has been a port since the Middle Ages, with a harbour here dating back to the twelfth century. Its situation on the east coast of Scotland made it ideal for trade with Europe. Until the nineteenth century the port consisted of a series of quays on the Water of Leith, but then developed as an area of enclosed docks.

The first dock to be opened at Leith was a dry dock in 1720, the first dry dock in Scotland. The first wet dock, the East Old Dock, was opened in 1806, followed by the West Old Dock in 1817. In 1846 the Victoria Dock was opened, following by the Albert Dock in 1869. Growth continued with the Edinburgh Dock in 1881 and the Imperial Dock in 1904, followed by the Imperial Dry Dock in 1912. As well as docks being built, breakwaters were constructed to form harbours.

Leith Docks provided employment for thousands of people, but after the First World War, some companies suffered major losses and did not survive. By 1930 trade depression had set in and more ships were laid up than were trading. Again some companies ceased trading. Trade started to pick up during the 1930s, but then war was declared in 1939, and many ships were lost during the Second World War.

By the 1960s container shipping was the popular and much more efficient way to ship goods, but Leith couldn't cope with the new larger ships. However, in 1969 a huge sea lock was installed, which transformed the tidal harbour into a deepwater port.

The Docks Commission, which was established in 1828, was taken over by the Forth Ports Authority in 1965.

There have been many huge changes to the docks and adjacent areas in recent years. West Old Dock and East Old Dock both closed in 1968, and they as well as Victoria Dock were filled in and development later took place on the land. Much of the new housing around the dock area is on reclaimed land. The Port of Leith is now also a Cruise Terminal, with around 20,000 passengers per year arriving here.

Above and below: Leith Docks, 2018.

Eldorado

The Eldorado in Mill Lane was a rather odd combination of ballroom and wrestling venue. In its heyday in the 1940s and 1950s, all of the big bands played there while touring the UK. Apparently house officers at the nearby Leith Hospital were entitled to free entry to the venue as a perk of the job. During the 1960s and into the early 1970s it hosted several pop and rock concerts by big names of the day including The Searchers, Brian Poole and the Tremeloes, Hawkwind, Sweet, Free and Deep Purple. In the late 1970s it was briefly a skateboard arena, and the proximity of Leith Hospital was appreciated by the many youngsters who suffered injuries through skateboarding there – reputedly more than the injuries from the wrestling over the years!

The Eldorado is no more after a fire on 15 July 1984, but lives on in the memories of many Leithers. Perhaps it lived up to its name for some of them, 'Eldorado' meaning 'any place of great riches or fabulous opportunity'.

Poster advertising wrestling at the Eldorado. (Reproduced with kind permission of Living Memory Association Archive)

F

J. D. Fergusson

John Duncan Fergusson, who is regarded as one of the major artists of the Scottish Colourists school of painting, was born in Leith on 9 March 1872.

After briefly training as a naval surgeon, Fergusson came to realise that his true vocation was art, and he enrolled at an Edinburgh-based art school. However, he disliked the rigid teaching style there and decided to teach himself to paint. He travelled in Spain, France and Morocco, where he met other artists, among whom was Samuel Peploe, who would also become a member of the Scottish Colourists. As well as painting, Fergusson was a talented sculptor, although some of his sculpted women were looked on unfavourably at the time due to their erotic undertones. In 1898 he visited Paris for the first time, where he was influenced by Impressionism and later by Fauvism. He lived in London and Paris, but returned to Scotland to live in Glasgow in 1939 at the outset of the Second World War, where he remained for the rest of his life.

Fergusson died on 30 January 1961 and is buried in Edinburgh's Dean Cemetery.

Firemarks

Before municipal fire brigades were formed, the job of firefighting fell upon the Fire Insurance Company brigades. Originally, insurance companies had salvage squads who were sent out to limit their losses, and these developed into fire brigades. The men who manned them, however, were untrained, and they only attended fires in which their company had a financial interest. The presence of a metal plate known as a firemark on the front of a building provided a means of identification so that the brigade knew the property was insured by them. The firemark was embossed with the company's motif and often the number of the policy. If the brigade arrived at a fire and found that the burning building was not one they had insured, nor were any nearby buildings, they would simply leave it to burn.

The firemark of the Caledonian Insurance Company is still visible on a building in Queen Charlotte Street.

Caledonian Firemark on building in Queen Charlotte Street.

Foot of the Walk

The area at the north or Leith end of Leith Walk is generally known as the Foot of the Walk, located where Leith Walk, Duke Street, Constitution Street, Great Junction Street and New Kirkgate meet, and has long been a place for people to meet and gather together. Over the decades, old men in flat caps, Teddy Boys, and housewives doing their shopping have been among the groups congregating here for a chat. The Salvation Army Band was also a regular feature here on Sunday afternoons.

The large building on the corner of Constitution Street and Duke Street, now a pub, was originally a purpose-built cinema, which opened in 1913. The cinema closed in 1966, and later became a bingo club and then a snooker hall. When it was being renovated as a pub in 2001, it was discovered that the cinema circle and balcony complete with seats were still there above the ceiling. Unfortunately, there is no public access to these surviving cinema seats.

A prominent feature at the Foot of the Walk is the bronze statue of Queen Victoria, sculpted by John Rhind, which was unveiled on 12 October 1907 by Lord Rosebery, watched by a crowd of over 20,000 people. The statue marked the reign of the late queen, who had died in 1901, and commemorated her visit to Leith in 1842. It is also a war memorial to the memory of local members of the Scots Guards who had died in the Boer War. The statue has been moved on two occasions for cleaning and restoration, and to allow for changes in traffic flow.

Above: Tram at Foot of the Walk, 1955. (© Kenneth Williamson)

Right: Queen Victoria statue.

G

Dick Gaughan

Richard Peter Gaughan was born in Glasgow on 17 May 1948, his place of birth being what he describes as 'a sheer accident of timing' as his father was temporarily working there at the time. The family, however, moved to Leith when he was less than two years old, where he grew up surrounded by Scottish and Irish music. Dick's father had been born in Leith of an Irish father, and his mother was a Highland Scot, whose first language was Gaelic. The family were poor, and many of Dick Gaughan's songs celebrate his working-class roots. Gaughan plays a wide range of musical styles, from jazz to rock to country, but his great love has always been old traditional Scottish ballads.

He wanted to be a musician from the time he first played a guitar at the age of seven, and got involved with the local folk music scene, starting up the Edinburgh Folk Centre with two others. He turned professional in 1970, moving to London where he recorded his first album in 1971. Gaughan briefly joined The Boys of the Lough, then resumed his solo career, mainly playing traditional songs. Next he joined Five Hand Reel, making three albums with them in the 1970s. In the 1990s, he joined with other established Scots musicians to form the acclaimed but short-lived Clan Alba.

In the twenty-first century he continued playing, recording and presenting a radio programme, and in 2009 was inducted into the Scots Trad Music Hall of Fame, followed in 2010 by a Lifetime Achievement Award at BBC Radio 2's Folk Awards Ceremony. Sadly, in 2016 Dick Gaughan announced that he was cancelling all public performances until further notice following a stroke.

Gibson's Aeroplanes

Leith is mainly associated with ships, but it also had its own aeroplane manufacturer in the early years of the twentieth century. John Gibson was originally a cycle maker and dealer, but from 1910 to 1913 he also described himself as an aeroplane designer and builder. From his shop at No. 109 Leith Walk and nearby workshop at No. 10 Manderston Street, he offered to build a plane to your own design, with 'planes,

tails, ailerons, supplied on receipt of measurements' and 'aeroplane fabric, all grades, at factory prices'. He also undertook aeroplane repairs. In 1911, he offered a complete biplane for the sum of £450.

Gibson's aeroplane business seems to have only lasted for a short period of time, and he then went back to cycle making.

Glassmaking

Glassmaking was an important industry in Leith from as far back as the seventeenth century.

The earliest mention of glassmaking in Leith is in 1663 when Robert Pape set up a glasswork at the Citadel, where he advertised that

> all sorts and quantities of glass are made and sould at the prices following: to wit, the wine glass at three shillings two boddels, the beer glass at two shillings sixpence, the quart bottel at eighteen shillings, the pynt bottel at nine shilling, the chopin bottel at four shillings sixpence, the muskin bottel at two shillings sixpence, all Scots money.

However, for some reason local merchants continued to import their glass, as they had done previously, and would not buy from Pape. His business survived about twelve years, until the final straw was the cashier absconding with a large sum of money. A group of men took over the business, but soon discovered that there was no one locally who was qualified for the highly skilled craft of glassmaking and it was necessary to bring men up from England. Their work turned out to be poor (and it was suspected that this was deliberate on their part) and the Citadel glasshouse eventually closed in 1681. The entire business was sold and, after a few false starts, it began to operate as the Leith Glass Company and specialised in bottle making to capitalise on the fact that Leith was the main Scottish port of entry for wine. The Leith Glass Company continued at the Citadel until 1728, after which the business was sold several times until a fire in 1747 brought glassmaking there to an end.

After the fire, glassmaking moved to Leith Sands, where the main product was green glass bottles for wine, later expanding into white glass bottles for chemists. A second company was set up in 1790, and between them the two companies were operating seven furnaces, employing between 400 and 500 men, with the skilled workers being some of the highest wage-earners in Leith.

This very prosperous industry was effectively destroyed by taxation. In 1745, the duty on glass bottles was 3s 4d per hundredweight, but by 1822 it had reached the incredible level of 98s per hundredweight, which eventually put the glassmakers out of business.

Salamander Street takes its name from the glassmaking furnaces, as the salamander in legend was said to be fireproof.

Glayva magazine advertisements from 1954.

Glayva

Yet another alcoholic beverage from Leith, Glayva was created in 1947 by wine and whisky merchant Ronald Morrison, who wanted a liqueur that was warming and comforting, especially during the cold Scottish winters. Glayva is made from a blend of Scotch whiskies, with tangerines, cinnamon, honey, almonds and spices, all of which were imported into Leith. It got its name when a Gaelic-speaking warehouseman declared it to be '*Gle Mhath*', meaning 'very good'.

Gretna Rail Disaster

On Saturday 22 May 1915, a troop train carrying members of the 7th (Leith) Battalion of the Royal Scots Territorials left Larbert, where they had been training, bound for Liverpool to then sail to the Dardanelles on what was to have been their first experience of active service.

Tragically, due to human error by railway signalmen, the troop train crashed into a stationary goods train at Quintinshill near Gretna, and minutes later the Glasgow-bound express train from London crashed into the already mangled wreckage. The wooden carriages of the troop train, lit by gaslighting, quickly ignited.

Gretna Memorial, Rosebank Cemetery, Pilrig Street.

The official death toll was 215 Royal Scots and twelve civilians; some died at the scene of the accident, others died months later from their injuries. Of the 215 soldiers, eighty-three bodies were identified, eighty-two were unrecognisable and couldn't be identified, and fifty couldn't even be traced. All that was left was small pieces of melted metal from buttons and belt buckles.

The *Scotsman* of 24 May 1915 reported on the tragedy and rather mawkishly stated,

> More than one poor fellow gave vent, in his dying agonies at Gretna Green, to his regret that he had not been able to strike a blow, in the battlefield or in the trenches, for the flag under which he enlisted.

The remains were brought back by train to Leith Central station, and the bodies laid out in Dalmeny Street Drill Hall. The *Scotsman* reported,

> The coffins ... were placed on wooden supports along two sides of the hall. In the space between were ranged two rows of palms. Each coffin was draped in a Union Jack, and on all of them floral tributes, consisting in some cases of large wreaths and in others of only a few lilies, had been placed.

A service was held at the drill hall on Monday, after which 101 coffins were conveyed to Rosebank Cemetery in Pilrig Street where they were laid to rest in one communal grave. The procession and burial service lasted three hours, and more than 3,000 soldiers lined the route from Dalmeny Street to Rosebank Cemetery.

The following day, the bodies of another twenty victims were brought to Leith, a second common grave was dug, and a second funeral held.

A memorial appeal was started, hoping to raise £2,000, made up of £500 for a monument and £1,500 to endow a bed in Leith Hospital. By April 1916, the fund had reached nearly £4,000, and it was decided in addition to make a donation to the Royal Scots Association as well as to some of the institutions near Gretna where the victims had been treated.

A monument was erected in Rosebank Cemetery, designed by George Simpson, the burgh architect, with panels containing the 7th Battalion crest, the Leith coat of arms and the Scottish Lion. Ten bronze panels on the wall behind were inscribed, in alphabetical order, with the names of those who had died. A Service of Dedication took place on 12 May 1916, attended by almost 2,000 people, including thirty survivors of the disaster, many of them using sticks and crutches.

H

Henderson Street

As you enter Henderson Street from Great Junction Street, there is a carved stone at first-floor level, which states that it is the 'Leith Improvement Scheme Memorial Stone, placed by the town council in the first building, February 1885, James Pringle, Provost'. It also contains the seal of Leith, with the motto 'Persevere' and the date 1563. There is also another carved stone just at the junction of Henderson Street and Yardheads marking the Leith Improvement Scheme First Artizans Dwellings.

Leith Improvement Scheme Memorial Stone, Henderson Street.

Stone marking first artizans dwellings in Leith Improvement Scheme, Yardheads.

Henderson Street itself was the main element of the Improvement Scheme of 1880, initiated by Dr John Henderson, provost of Leith from 1875 to 1884, whose name was given to the street.

The construction of the street required eighteen closes to be demolished in order to make way for the new buildings and layout, and many of the historical names were lost forever, including Green Jenny Lane, Vinegar Close, Peat Neuk and Sheephead Wynd. The area demolished had around 3,500 inhabitants and it was planned that the new housing would accommodate nearly double that sum. At that time housing conditions in this part of Leith were very poor, with overcrowding, poverty and ill health. It was, therefore, hoped that the creation of Henderson Street would improve living conditions for the local residents, which it surely did, albeit with the loss of a great amount of local history and character.

Governor John Hunter

John Hunter was born in Leith on 29 August 1737, the son of a Leith shipmaster, and went on to achieve fame on the opposite side of the world.

Hunter received a classical school education and was sent to the University of Edinburgh, but soon left to join the navy in 1754. He served on various ships as a midshipman during the Seven Years' War, and remained active during peacetime, sailing to North America and the West Indies where he was master of a succession of ships.

H

He served during the American War of Independence, after which he became a lieutenant and then was promoted to post captain and was second-in-command on board HMS *Sirius* to Arthur Phillip, who sailed to Australia and founded the colony of New South Wales in 1788. In October 1788, Hunter was ordered to the Cape of Good Hope for supplies. He sailed around Cape Horn to the Cape of Good Hope, and returned to New South Wales in May 1789, thus circumnavigating the globe.

Hunter and some of his men returned to England, and when Arthur Phillip resigned from his governorship of New South Wales in 1793, Hunter applied for and was appointed to the position. He returned to Australia and took up the governorship in 1795, where he remained until 1800. Hunter was described by a contemporary as 'most accomplished in his profession, and, to sum up all, a worthy man'.

On his return to England, Hunter continued to serve in the Royal Navy, eventually reaching the rank of vice-admiral. He spent much of his final years of retirement in Leith at No. 5 Cassels Place (now part of Leith Walk), and died at his London home on 13 March 1821.

Bust of Governor John Hunter at the Shore.

International Community

Today Leith has a very cosmopolitan feel, with restaurants and cafés serving food and drink from a multitude of countries but, as with all ports, Leith has seen visitors from many parts of the world for several centuries, with people of many different nationalities making their home here. Scotland and the Port of Leith have also for centuries enjoyed close trading and cultural links with France and several other European countries.

In the 1840s, as a result of the Potato Famine, many Irish people travelled to Scotland to seek work and make their homes here. Then from the late nineteenth century onwards, many Italians migrated to Scotland, and of course many of them settled in Leith and established businesses there. A National Library of Scotland survey of Italians living in Scotland in the 1930s shows many in Leith, and of those who stated their occupations, there were many confectioners, owners of cafés and fish restaurants, as well as a smattering of hairdressers and barbers. Sadly, during the Second World War many Italian businesses were attacked and looted as anti-Italian feeling grew, and many Italians were interned and deported overseas.

One of the longest established Italian businesses in the area, although not actually in Leith itself, is Valvona & Crolla in Elm Row, which was founded in 1934. During the wartime rioting, their display windows were boarded up, and even today the upper parts are still boarded, acting as a lasting reminder of those days.

People were emigrating from Asia to Scotland from as early as the 1930s, but after the Partition of India in 1947, the military and social climate in and around that region resulted in high levels of immigration, with many Asians of various faiths making their homes in Leith. In 1964 the first Gurdwara in Edinburgh was established by the Sikh community in Hopefield Terrace, Leith. After a move in 1970 to larger premises, in 1976 they moved to their current home in the former St Thomas' Church at Sheriff Brae, initially only using the lower floor but, after an arson attack in 1989, the interior was reconstructed with two floors. The Sikh community are very firmly integrated in Leith, maintaining not only their own traditional culture but also becoming very much a part of Scotland's diverse cultural make-up, and it's not unusual to see some of their young men dressed in a kilt and a turban on special occasions.

Other faiths and cultures have also made Leith their home, and have established places of worship for the Hindu, Muslim and Buddhist communities.

From 1869 to 1973 there was a Norwegian Seaman's Church in North Junction Street, the building of which is now Leith School of Art.

The latest wave of immigration has been from Eastern Europe, with many people from that part of the world now making their home in Leith. This move to Leith from Eastern Europe is nothing new, however, as many of their countrymen had already settled here after the Second World War.

Right: Brightly coloured Asian dresses.

Below: A collage of Leith shop signs.

J

Junction Bridge

Junction Bridge, close to where Great Junction Street meets Ferry Road, now carries a busy main road across the Water of Leith. In previous times it also crossed a railway line with Junction Bridge station underneath the bridge itself on the north bank of the Water of Leith. Great Junction Street was planned around 1800 as a means of joining the foot of Leith Walk with Ferry Road and bypassing the narrow streets of old Leith.

The bridge consists of one semicircular stone arch over the river and a much flatter stone arch over the former railway line. The original bridge was constructed in 1818, although the railway line didn't open until 1869, so the smaller arch may have been added at that later date. In 1909 the whole bridge was widened to provide a much broader roadway.

Access to the station was available from both sides of the road until it closed in 1947, with the former entrances now blocked by railings. The Water of Leith Walkway now passes under Junction Bridge, along the route of the former railway.

Junction Bridge and the former State Cinema from the Water of Leith walkway.

K

King's Landing

The King's Landing at the Shore marks the point where George IV arrived in Leith on 15 August 1822 on board his yacht *The Royal George*, the first visit to Scotland by a reigning monarch for over 150 years. The visit had been postponed by one day due to torrential rain on the preceding day.

Thousands of people turned out to greet the king including Sir Walter Scott, the main person behind this visit, splendidly dressed in tartan. The visit to Leith and Edinburgh was a huge success and resulted in an increase in goodwill towards the crown, and had a lasting influence, with the kilt becoming part of the Scottish national identity from this time. It is said that Sir Walter Scott pocketed a glass from which His Majesty had drunk wine as a souvenir, but forgot about it and later sat down and crushed it to pieces.

King's Landing plaque commemorating George IV landing in Leith.

The king himself is variously described as wearing naval uniform or wearing a kilt with pink tights, but it seems most likely that the kilt was worn at an event he attended at Holyrood Palace during his visit, not when he disembarked at Leith. The reason for the pink tights seems to be that he didn't want his fat white knees to be seen!

The artist J. M. W. Turner made several sketches of the occasion, which are now in the collection of the Tate, and paintings by David Wilkie and Alexander Carse also commemorate the royal visit.

King's Wark

The original King's Wark or Palace was initiated by James I around 1434 as a residence, storehouse and armoury, but was not completed until around 1500.

During the first invasion of the English Earl of Hertford in 1544, the Wark was virtually destroyed, but was partially rebuilt in 1561–64 by Queen Mary's Comptroller

King's Wark, the Shore.

K

of Artillery, John Chisholme, and later converted into a plague hospital. It was redeveloped for James VI, to include a tennis court, which was described as affording great satisfaction and delight to His Majesty and his visitors. In 1614, James VI gave the building to his favourite groom of the chamber, Bernard Lindsay (after whom the nearby Bernard Street was named) 'empowering him to keep 4 taverns on the site'. In 1649 it was again repaired and the tennis court converted into a weigh house, but was destroyed by fire in 1690, and by 1752 had undergone further reconstruction.

Between 1799 and 1822 the building was occupied by merchants Ramsay Williamson & Co., and from around 1855 it was owned and occupied by Rutherford & Co., a wholesale and retail wine and spirit merchants. By 1959 it had been taken over by E. Cranston, another wine and spirit merchant.

The present building dates largely from the early eighteenth century, was extensively restored during the 1970s, and now contains flats as well as the popular King's Wark pub.

Kirkgate

The Kirkgate was very much the heart of old Leith, running northwards from the foot of Leith Walk towards the docks area.

The street took its name from being literally the road to the kirk, South Leith Parish Church, and was a busy, thriving thoroughfare packed with shops and houses. It had

Kirkgate stone commemorating Cant's Ordinary.

an enormous choice of shops including greengrocers, butchers, shoe shops, grocers, sweetie shops, drapers, victual dealers, ships' chandlers, a record shop, as well as bars, cafés, tearooms, hairdressers and the Gaiety Theatre.

One famous old building in the Kirkgate was Cant's Ordinary, an ancient tavern that had been visited by Charles II, Oliver Cromwell, Queen Mary and the elite of the sixteenth and seventeenth centuries, and which was demolished in 1888. The Victorian building that replaced it had a commemorative plaque on its façade, which can now be seen on a block of 1960s flats, which are approximately on the site of the tavern.

The Kirkgate and adjoining streets were all demolished in the 1960s, leaving behind only Trinity House and South Leith Parish Church, and replaced by the New Kirkgate Shopping Centre, a community centre and modern housing. The housing arguably was an improvement on the old buildings that it replaced, but the destruction of the Kirkgate and its adjoining streets and lanes removed the whole focus and character of the area, the place where generations of Leithers had lived, worked and played.

Kirkgate shortly before demolition. (Reproduced by kind permission of Jack Gillon)

L

Lamb's House

Lamb's House, named after its original owner Andrew Lamb, is the only surviving early seventeenth-century domestic building in Leith, and is typical of the properties built by prosperous maltmen, skippers and merchants. Built around 1610 of sandstone rubble with a red pantiled roof, it is an impressive four-storey building with crow-stepped gables and tall chimneys, and is sited at the corner of Burgess Street and Water Street.

The seventeenth-century Lamb's House.

In its heyday it was one of the grandest properties in Leith, but by the beginning of the twentieth century it was occupied by as many as eight families, and by the 1930s it was in a semi-ruined state and in danger of being demolished. The Marquess of Bute purchased the property in 1938 and spent a large sum of money on its restoration before donating it to the National Trust for Scotland in 1958. By the 1960s it was being leased from the National Trust for Scotland and converted for use as an old people's day centre, and again its condition was allowed to deteriorate. The property was Category A listed in 1970 because of its historic and architectural importance.

At one point there were plans to convert it into flats but, thankfully, in 2010 the building was sold to conservation architects Andrew Groves-Raines and Kristin Hannesdottir, who painstakingly restored the property. All materials used were as similar as possible to the originals and the house is now their home and workplace.

Dr Thomas Latta

Thomas Aitchison Latta, born in 1796, was a medical pioneer who introduced the saline solution (saline drip) into the treatment of patients. He attended the University of Edinburgh, graduating in 1819 with his thesis about scurvy.

The saline drip was introduced by Dr Latta during a cholera epidemic in 1832, which was killing huge numbers of people. Dr Latta, along with his colleagues Dr Thomas Craigie and Dr Robert Lewins, was based in Leith, although the experiments were carried out on patients in the Edinburgh Cholera Hospital in Drummond Street, Edinburgh. His results were good and effective in saving human life, but his research didn't come into wide use until some seventy years later. Dr Latta's theory was basically that a salt solution could substitute for blood. As cholera was inevitably fatal, there was nothing to lose by allowing Dr Latta to try out his treatment, which was administered intravenously, on patients. He described how an elderly patient, who was apparently in the final stages of the disease, began to regain normal temperature and pulse rate, breathing became less laboured, and appeared to be restored to health by the use of his saline solution. However, although some of his patients did survive, most died after a temporary period of improved health. This was almost certainly because Latta was unable to gauge the correct proportions of chemicals to use, and standard use of saline solutions only began in 1902 when electrolyte balance was better understood.

Latta was based at Leith Hospital, and had a property in Charlotte Street (now Queen Charlotte Street). He died in 1833 and is believed to be buried in the small graveyard at North Leith Parish Church on Madeira Street.

In 2014, a new street, on the site of the Eastern General Hospital in Leith, was named Latta Place in his memory.

Leith Airport

For a brief time during the 1950s, Leith had its own airport. At the end of 1949, Christian Salvesen & Co. wrote to the Docks Commissioner on behalf of Aquila Airways of London, who wished to arrange a scheduled seaplane service between Leith and Falmouth, requesting that Leith be licensed as an airport. The intention was to run a weekly service between May and October. A licence was obtained at a cost of £1 5s for the first year, and £1 1s yearly thereafter.

The airport opened on 1 June 1950, with an inaugural flight from Southampton landing at Leith the following day, but later that same month Aquila Airways wrote to explain that, due to an almost total lack of bookings, they were postponing the service. The Commission continued to renew its licence each year, and in 1952 four American Mariner flying boats landed at Leith, but they were to be the only users of the airport and the licence was discontinued in 1959.

Aquila Airways themselves, a commercial flying boat operator, were only in business from 1948 to 1958.

Leith Bank

Leith Banking Company was founded in 1793, and by 1806 was trading from an elegant two-storey building in Bernard Street, which was designed by John Patterson in classical mode with Ionic columns and a bow-style dome. The early nineteenth

Former Leith Bank building in Bernard Street.

century was a time of great prosperity for Leith, and the bank prospered initially, and even had branches in other towns and provided services at agricultural markets.

Leith Bank issued its own notes including a one guinea note, which depicted George IV at the King's Landing with the Custom House in the background.

The bank failed in 1842 due to debt, and was reincorporated as the Edinburgh and Leith Bank. The original premises were taken over by the National Bank, now amalgamated with the Royal Bank of Scotland. The building is now the home of Kagyu Samye Dzong Edinburgh, a Tibetan Buddhist Meditation Centre.

Leith Central Station

Leith Central station, which opened in 1903, covered a huge area, running all the way from Leith Walk to Easter Road. It was similar in size to Princes Street railway station and it was apparently the Caledonian Railway's ambitious plans to complete a circular route of North Edinburgh by building an extension to its existing Newhaven branch via Leith and an extensive tunnel under Calton Hill and under George Street back to Princes Street station, which led to the construction of Leith Central by North British Railway, who were the largest operator in Leith and were not happy about the Caledonian Railway's plans.

Leith Central station buildings.

Derelict Leith Central station, 1980s. (© A. Murray Wilson)

Leith Central station had an 18-metre-high glass canopy roof, supported by girders. At Leith Walk the station was entered by doors on the corner of Duke Street, which led upstairs to the ticket office, waiting rooms and the four platforms. At ground-floor level there were shops on the Leith Walk and Duke Street sides, as well as the Central Bar, which still exists. There was also an entrance to the platforms at the Easter Road end of the station.

The station closed on 7 April 1952 and was then adapted to become a depot for the new trains used on express services between Edinburgh Waverley and Glasgow Queen Street. By the early 1970s these trains were becoming unreliable and were replaced in 1971, thus making Leith Central redundant as a depot. It finally closed completely in 1972 and was allowed to become derelict.

In the 1980s the abandoned station was notorious for being used by drug addicts, and this was the inspiration for a scene and the title of *Trainspotting* by Irvine Welsh.

The train shed was demolished in 1987 and a Tesco supermarket now occupies much of the site. All that presently remains of the station is the terminal building and clock tower.

Leith Citadel

In the 1650s Oliver Cromwell's London-based government ruled Scotland. Following the Scottish army's heavy defeat at the Battle of Dunbar, Cromwell's army, commanded by General Monck, took possession of Leith, decided to strengthen Leith's defences, and at one stage proposed to surround the entire town with fortifications. The town council of

Leith Citadel.

Edinburgh were alarmed by this, and offered £5,000 towards the cost of building a citadel instead. The Citadel was built by John Mylne in North Leith on the site of St Nicholas' Church, which was demolished for that purpose, at a cost of £100,000, which was an enormous amount at the time. It was a large pentagonal construction with walls faced with hewn stone and a large central courtyard. It had five bastions, one at each corner, with barracks and a stone building for magazines and stores and also houses for the governor and officers. The area originally covered was Dock Street, Coburg Street, Cooper Street, then following the line of the old 1560 fortifications to what is now Commercial Street.

When Monck left Scotland in early 1660, he left Major-General Thomas Morgan in command of the garrison. After Charles II was restored to the monarchy in 1660, the garrison was retained in case there was any armed resistance to the restoration of the monarchy. By 1662 the only forces remaining in Scotland were two regiments of foot and a troop of horse, which were centred on Leith Citadel. They had refused to disband until arrears were paid to them, and following settlement they departed and the Citadel was given to the Earl of Lauderdale.

Lauderdale persuaded Edinburgh to buy it back from him, and within ten years it was disused and partially demolished. The remains became a prison and were captured by the Jacobites in 1715, and the prisoners released.

Leith Citadel.

The Citadel site was briefly used for industrial purposes and one of the first genuinely Scottish newspapers, the *Mercurious Caledonius*, was produced here. The Citadel also became a fashionable place in which to live.

Today only one gate, or port, remains on the west side of Dock Street, which consists of a vaulted pend with an arched gateway at either end.

A–Z of Leith

Leith Fort

John Paul Jones, the Scots-born founder of the American navy, sailed up the Forth with three warships in 1779 during the American War of Independence and threatened to capture Leith. At the time, Leith had no adequate defences, but fortunately high winds forced the American ships out of the Forth.

A battery of nine guns was hastily erected to cover the entrance to the harbour. The authorities decided that a more substantial defence was necessary and James Craig, who had won first prize for his design for the New Town, was commissioned to draw up plans for a fort in Leith.

The 1st Royal Artillery Company arrived in September 1793 to occupy the fort with a detachment of infantry from Edinburgh Castle but no guns were ever fired in anger.

In the early nineteenth century the fort was brought into use as a prison for French captives from the Napoleonic Wars. The fort's first claim to fame was in 1824 when the gunners hauled their fire engine up to the High Street to help fight the 'Great Fire of Edinburgh'.

Leith Fort guardhouse.

Leith Fort entrance.

The second was in 1861. Captains of ships anchored in the Forth set their chronometers by the ball at Nelson's Monument on Calton Hill, but as the ball could not be seen in misty weather an audible signal was required. A gun from Leith Fort was set up on the Castle's Half Moon Battery, connected electronically to the time ball and so the 'One O'clock Gun' was fired for the first time.

Leith Fort was the base for the Royal Artillery until after the Second World War, and then became a National Service training centre, with the Royal Army Pay Corps being the last military unit stationed there. It had its final official parade in April 1956.

The fort's interior was demolished to make way for housing, with the perimeter wall, entrance gate and guardhouse all left standing. Fort House was built between 1957 and 1963 as public housing. Unfortunately, like many other housing estates at the time, it suffered from vandalism, drug use, and other anti-social behaviour and was eventually demolished in 2013 to make way for new affordable housing, where the history is remembered in the street names – John Paul Jones View, Guardhouse Parade, and Cannon Wynd.

Leith Hospital

Leith Hospital was formed from three bodies: firstly, the Humane Society, which came to Edinburgh and Leith in 1788 and was mainly concerned with the resuscitation of drowning victims; secondly, Leith Dispensary, which was an outpatient facility opened in 1816; and thirdly the Casualty Hospital, opened in 1837.

Entrance to the original Leith Hospital building in Mill Lane.

By the 1840s, Leith was a burgh of some 40,000 people and there was pressure to establish a hospital. At an inaugural meeting in 1846 it was agreed to start fundraising for a new 'Leith Hospital'. It was a few years before a suitable site could be found, a plot of land at Sheriff Brae being purchased in 1849, and the foundation stone was laid on 11 March 1850. The new hospital, which opened in July 1851, was a two-storey building with Roman Doric pedimented portico, facing onto Mill Lane, the upper floor being a fever hospital with four wards, and the ground floor having three wards and a dispensary. In its first year the hospital dealt with 2,344 dispensary patients, 268 casualty patients, 122 fever patients and eight submersions, so it was obvious from the start that there was a need for such a hospital in Leith.

In 1874 the surgeon to the Royal Navy requested that Leith Hospital provide medical facilities for sailors, which was agreed to, and continued for many years. In 1875 an extension was built in King Street, with another in 1889–90, the wards being named after benefactors and supporters. As a voluntary hospital, Leith Hospital depended on donations from local institutions and individuals. In 1896 there was a public appeal for £12,000 to increase the number of beds to 100. There was a plan for a three-storey surgical block facing onto King Street, with a nurses' home, kitchen and laundry across the road and connected to the main hospital by a subway, at a total cost of £24,000, which was adequately covered by donations and was opened in 1903 to mark Queen Victoria's Diamond Jubilee which had taken place in 1897.

Right: The former nurses' home in King Street, Leith Hospital.

Below: Leith's war memorial – the former Children's Wing of Leith Hospital.

After the First World War, as communities throughout the land raised funds for war memorials, the Leith community decided that their war memorial should take the form of a children's wing for Leith Hospital. Fundraising started in 1919, with great generosity from many benefactors, some of whom endowed beds in memory of relatives killed in action in the war. The new building of six wards, thirty-six beds in total, opened in 1927. In 1925 a chapel had also been added in the hospital grounds.

As the costs of running a modern hospital with new technology continued to escalate, raising funds for Leith Hospital was an ongoing problem until it was taken over by the National Health Service, which was formed in 1948.

Leith Hospital closed in 1987, with the plan that it would become a community hospital with outpatient clinics and diagnostic and treatment facilities. However, the buildings were sold and converted to residential units.

Leith Links

Leith Links has played an important part in history, as it was the site of the Siege of Leith in 1560. Scottish and English troops created siege trenches on the links, and two mounds remaining on the Links, 'Giant's Brae' and 'Lady Fyfe's Brae', are Scheduled Monuments as gun positions or artillery mounts, which were created for the siege. There has been doubt expressed by some historians as to whether these were in fact where the batteries were situated, but they became noted as such in a book published in 1827, and were thus saved when other hillocks were removed in 1888. One possibility is that Giant's Brae may in fact be an ancient burial mound.

Giant's Brae, Leith Links.

L

In 1744 on Leith Links the first official rules of the game of golf were formulated by the Honourable Company of Edinburgh Golfers, and a plaque on a stone cairn at the western edge of the links describes how the game was played over five holes.

When the area became a public park in 1888, cast-iron railings enclosed the entire area, but these were removed during the Second World War as part of the war effort and never replaced. During the creation of the park, two communal burial areas were discovered, which are thought to have been plague pits dating back to 1645.

Leith Links today is a large open public park of some 46 acres (0.18 square km), which was originally public grazing land and then a golf course before being formalised as a public park. It consists of two main areas divided by a roadway, both being mainly flat expanses of grass criss-crossed by pathways and bordered by trees. It has children's play areas, football pitches, public bowling greens, tennis and petanque courts, and an informal cricket pitch. It also has allotments, which were created during the Second World War and are still in use. It is very much a community space, with local schools and other community groups having been involved in planting spring bulbs and creating an orchard. It is a focal point of the Leith Festival and Gala Day each summer, and Leith Links is also the home of the Edinburgh Mela, an annual festival of music, dance and arts, which celebrates Scotland's diverse culture.

Leith Links, the home of golf.

A–Z of Leith

Leith Theatre

Leith Theatre is part of a civic complex that was a gift from the people of Edinburgh to the people of Leith to mark the decision to incorporate Leith into Edinburgh in 1920. Work started in 1929 and it opened in 1932. The complex also includes a public library, registrar's office and the Thomas Morton Hall. It has a classical façade and a sumptuous art deco circular entrance and box office, which leads to the main auditorium.

The building, which was initially the town hall, suffered bomb damage in 1941 and was closed until 1961 when it was converted into a 1,500-seat theatre. From 1961 to 1968 it was used as an Edinburgh International Festival venue, and during the 1970s it hosted many concerts including Mott the Hoople, Thin Lizzy, and AC/DC. It continued to host Edinburgh International Festival performances during the 1980s until its closure in 1988, since when it has been allowed to fall into a state of disrepair.

Leith Theatre Trust presently has a lease of the building from the City of Edinburgh Council, and intends to restore the theatre for use as a flexible performance space. The campaign to revive Leith Theatre received a welcome boost in February 2018 with £1 million of funding confirmed in the City of Edinburgh Council's capital budget for

Below left: Leith Theatre's original ticket booths.

Below right: Leith Theatre's main foyer and staircase.

Leith Theatre's auditorium.

2018–2023. This commitment is the first major capital contribution to the project, which aims to transform the main auditorium, along with other spaces within the complex, into a multispace, accessible venue supporting arts, community and events. In 2018 the theatre was once again chosen as an Edinburgh International Festival venue.

Leith Walk

In 1650 a 1.6-kilometre-long trench and mound, over 27 metres wide at its base, was constructed from the St Anthony Port in Leith to the Craigend (or Calton) in Edinburgh, which was intended to act as a defence against the anticipated advance of Cromwell's army, which never materialised. The mound remained, however, and the parapet became known as The Walk to Leith.

In 1748, Leith Walk was described as 'a handsome gravel walk, twenty feet broad, which is kept in good repair at the public charge, and no horses suffered to come upon it'. By the mid-1800s, the road was described as being in a deplorable condition, and in wet weather resembling 'a series of miniature fish ponds', a state that sadly many roads in Edinburgh and Leith resemble nowadays.

Leith Walk, looking towards the Foot of the Walk.

In 1776 the town had the road and walk reconstructed as a single metalled highway, which is why it remains as such a wide road today.

In the 1840s, Robert Chambers described Leith Walk as having been a place of wonderment: 'From top to bottom it was a scene of wonders and enjoyment peculiarly devoted to children.' He went on to mention panoramas, waxworks, and monkeys dressed like soldiers and sailors. One rather more sinister aspect of Leith Walk was the presence of a permanent gibbet at Gallow Lee, on rising ground close to Shrub Hill, which was the scene of execution of accused witches in the seventeenth century.

Many of the properties bordering it had been established before 1776 and already had street names, most of which are still in use today, so while the actual road is called Leith Walk, many of the buildings have different street names, such as Haddington Place, Crighton Place, and Albert Place.

M

Martello Tower

The Martello Tower, known locally as the Tally Toor, was built on Mussel Cape Rocks near Leith in 1809 at a cost of £17,000 as part of a scheme to defend the new docks and the city of Edinburgh against possible attack by the French during the Napoleonic War. The tower was around 10 metres high and 2 metres thick, of solid brick and stone.

The name comes from a misspelling of the original tower, which was at Mortella Point in Corsica, on which later versions were modelled. Towers would normally be divided into two floors, with storage rooms for food and ammunition and garrisons for one officer and between fifteen and twenty-five soldiers. Entry to the tower would be via a ladder through a high door, and the top platform would be used for a rotating artillery piece.

Martello Tower from a nineteenth-century drawing.

When the French invasion failed to materialise, the tower was left to decay until 1850 when it was renovated by the Royal Engineers and occupied by artillerymen until 1869. It was then abandoned and never used again. It was a popular place for an outing by Leithers, with a nearby stretch of sands on the west side of the docks, but is now land-locked and half buried on land belonging to Forth Ports.

Merchant Navy Memorial

This memorial is appropriately located on the site of the ancient Inner Harbour of Leith, opposite the former Sailors' Home (now the Malmaison Hotel), and was unveiled in November 2010.

Standing 5.5 metres tall, the sandstone column is decorated with cast bronze reliefs showing ships and seafaring scenes, as well as intricately detailed miniature figures.

It commemorates more than 6,500 Scottish Merchant Navy personnel who died during the First and Second World Wars, as well as those who lost their lives in

Merchant Navy Memorial.

other conflicts and during peacetime along the trading routes of the world. It is also a tribute to the 132 years of service to the Merchant Navy by Leith Nautical College between 1855 and 1987 with its training ship, the *Dolphin*.

The memorial was created by sculptor Jill Watson, and the bronzes were cast locally at Powderhall Bronze Foundry, with the cost of the memorial being raised entirely by public and private donations.

Mural

The huge mural on a tenement gable end in North Junction Street was painted in 1986 by Street Artworks, a partnership between artists Tim Chalk and Paul Grime, and was based on material gathered from members of the Leith Local History Project during workshops in 1985.

The mural was planned as a work of art that gave a voice to the local people and told their story, and it shows many aspects of life in Leith through the years. It has sadly become faded and worn in places, but is still a very striking piece of public art.

Mural on gable end at North Junction Street.

N

North Leith Churchyard

With only a few dozen headstones, this small graveyard by the Water of Leith in Coburg Street could easily be overlooked, but it has a fascinating history and connections to the sea. Burials took place here between 1664 and 1820, and many of the gravestones reflect Leith's maritime history, identifying those buried there as shipmasters, shipowners, merchants, and one as a purser in the Royal Navy. Sadly, many of the sandstone gravestones are so worn that it's impossible to read the lettering on them, but there are still wonderful examples of skull and crossbones and angels to be seen. Among other historic burials there is the altar

Below left and right: Ancient gravestones in North Leith Churchyard, Coburg Street.

tomb of Thomas Gladstone, grandfather of William Ewart Gladstone, who became the Liberal Prime Minister in 1868.

Around the beginning of the twenty-first century the graveyard, like many others, was being plagued by vandalism and anti-social behaviour. In an attempt to deter this, a block of new flats was built overlooking the graveyard, with the city council specially lifting their own planning rules, which barred development so close to cemeteries. They stated that in this case 'this relationship exactly replicates the historical relationship of buildings to the graveyard'.

It may seem odd that this burial ground is known as a 'churchyard' when it isn't adjacent to a church. The original churchyard was further to the north, but when the Citadel was built, new ground on this site was granted to the parishioners of North Leith Church in 1664.

North Leith Parish Church

The foundation stone of North Leith Parish Church in Madeira Street, designed by William Burn with a Greek Doric portico and clock tower with a spire, was laid on 11 April 1814, and the church opened for worship on 1 September 1816. At the time the site in Madeira Street made the building a focal point, although it is now in a heavily built-up area.

The roots of North Leith Parish Church date back to 1493 when a chapel dedicated to St Ninian was built on the north-west bank of the Water of Leith. The building was almost certainly extensively damaged by English raids in 1544 and 1547, and after the Reformation it was rebuilt on a larger scale to meet the needs of the increasing population. At this time it was little more than four walls and a roof, with no pulpit and no pews. In 1606 the full status of parish church was conferred by an Act passed by the Scottish Parliament. Part of this building still remains, known as St Ninian's Manse.

A second chapel, which was dedicated to St Nicholas, the patron saint of seafarers, also stood in North Leith until it was demolished in 1656 to make way for the Citadel, but its precise location and origin is unknown.

St Ninian's Church was renovated in 1736 following the discovery of serious rot in the roof timbers, but by the end of the eighteenth century the congregation had outgrown the available space, and the present-day church in Madeira Street was built.

The church building was badly damaged in 1941 when a land mine was dropped during an air raid, which caused considerable damage across North Leith. All of the upstairs windows were shattered, the crypt was damaged, and the blast caused some movement in the foundations. Services had to be moved to the Church Hall, but by 1948 the foundations had settled again and repair work was begun followed by major renovations. The church reopened in May 1950, was rededicated, and has been used

North Leith Parish Church, Madeira Street.

ever since. Further repair and renovation work took place in the early 1990s, and in 1993 the congregation celebrated the 500th anniversary of a Christian presence in North Leith.

O

Ocean Terminal

Ocean Terminal is Edinburgh's biggest indoor shopping centre. Designed by Sir Terence Conran, it opened in 2001 on former docklands. As well as over seventy shops, Ocean Terminal has a wide selection of restaurants with stunning views, a twenty-four-hour gym, a twelve-screen cinema, soft-play area and indoor roller skating rink. A free multistorey car park offers direct access to the shopping centre without having to go outside, and Ocean Terminal tends not to be as busy as city centre shops, which makes for a more relaxing experience. Its really unique point, however, is the royal yacht *Britannia*, which is permanently berthed alongside Ocean Terminal, and accessed via the visitor centre within the shopping centre.

Somewhat ironically, Ocean Terminal is built on the site of Henry Robb's, the last shipyard in Leith, which closed in 1984.

Ocean Terminal.

Dean Owens

Dean Owens is widely recognised as one of Scotland's finest singer/songwriters, and in 2017 was the first Scottish musician to officially showcase at the prestigious Americanafest in Nashville.

Born and brought up in Leith, Dean has also been strongly influenced by American musicians, and the music of Nashville, where he has recorded three of his solo albums, in particular. A proud Leither, many of his songs also draw inspiration from his upbringing, including his celebrated *Man From Leith* (from his *Whisky Hearts* album), which has been hailed as a classic of Scottish songwriting.

Armed with a searingly soulful voice, skilfully crafted stories and earworm-generating melodies, Dean's music conjures the open road's wild romanticism while searching for and combining the primal sounds of two very different countries. His music has been described as Celtic Americana from Leith via Nashville, and Celtic spirit, country soul.

Dean has released seven solo albums to date, with his most recent, *Southern Wind*, recorded in Nashville with regular collaborator, award-winning guitarist Will Kimbrough and producer Neilson Hubbard, and released in February 2018 to wide acclaim, particularly for its 'unique blend of Scottish and Americana roots music'.

Owens' first serious band was Smile, formed with bass player Kevin McGuire, guitarist Calais Brown and drummer Dave Stewart around 1991/92. Their first single, *Obvious*, reached number twenty in the Scottish Charts.

The Felsons rose from the ashes of Smile. Built round the core of Owens and McGuire, developing their signature Celtabilly sound, they released their first album, *One Step Ahead of the Posse*, in 1996, and a follow-up mini album, *Lasso The Moon*. They were joined by old Smile pal Calais Brown and released their third album *Glad* on famous Scottish label Greentrax subsidiary G2. The Felsons toured widely, including an extensive US tour supporting the Mavericks, before Dean started working on his solo career, which has taken him around the world including tours in Europe and Australia.

Dean Owens. (© Neilson Hubbard)

P

Persevere

The motto of Leith, which appears on the coat of arms, is 'Persevere'. The arms were granted on 27 February 1889, and show the Virgin and Child seated in a ship with a cloud above. The ship denotes the port and its seagoing trade, and South Leith Parish Church is dedicated to St Mary. A similar image appears on a seal dated 1563, and the crest can still be seen on lampposts and old buildings in Leith.

When Leith became part of Edinburgh in 1920 it lost the right to its historic coat of arms, and the court of the Lord Lyon, the heraldic authority for Scotland, took responsibility for the crest.

However, in 2012, after a long-running campaign by Leithers, who indeed lived up to their motto, the coat of arms, with a slight variation in colour, was granted to the Leith Neighbourhood Partnership, who now have the right to use it on their website and paperwork.

Above: 'Persevere' on a paving stone on Water of Leith walkway.

Right: Detail of Leith lamp post showing the motto 'Persevere'.

A–Z of Leith

Pilrig

The area of Pilrig sits on the boundary between Edinburgh and Leith. Being in this 'no man's land' historically caused problems with transport. From 1871 to 1899 a horse tram service ran up the entire length of Leith Walk. However, when Edinburgh installed a cable tram system down as far as Pilrig in October 1899, Leith Town Council refused to allow it to be extended to the Foot of the Walk. This meant anyone who wanted to travel the full length of Leith Walk had to change trams at Pilrig, which became known as the 'Pilrig Muddle'. In 1905, Leith installed electric trams, while Edinburgh still had the cable tram system until the 1920s.

Pilrig Park, which was originally the grounds of Pilrig House, is a large area of land that came into the ownership of the city of Edinburgh in 1920. Pilrig House itself was built in 1638, and was bought and remodelled by the Balfour family in 1709. One occupant of Pilrig House was Margaret Balfour, the mother of Robert Louis Stevenson.

Although the park was taken over by the city in 1920, the house remained privately owned until the death of the remaining sisters who lived there. After being taken over by the council, the house served as a fireman's hostel and then a hostel for homeless women until it became disused in 1970. It was virtually destroyed by two major fires, but was meticulously rebuilt in 1984 to externally resemble its original appearance, although internally it was divided into six flats.

Pilrig House in Pilrig Park.

Pilrig St Paul's Church.

Pilrig St Paul's Church is a major landmark at the junction of Pilrig Street and Leith Walk, which first opened for public worship in 1843. The present building was designed in French Gothic style and opened in 1863. A pipe organ, partly funded by the Scottish philanthropist Andrew Carnegie, was installed in 1903.

Plague

Leith, like most ports, suffered from plague many times over the centuries, and drastic measures had to be taken to try to stop the spread of the disease.

In the plague of 1495–96, the king ordered that all infected persons and their attendees were to be taken to Inchkeith (a small island in the Firth of Forth) and to remain there until their health had improved. Any infected person who wasn't on Inchkeith by sunset the following Monday would be branded on the cheek and banished from the burgh. As there was no known cure, isolation had been found to be the only way to limit the spread of the disease.

In June 1499 plague was so bad in Leith that Edinburgh Council forbade all contact with the port. Further plagues infected Leith in 1545 and 1569.

The biggest and most deadly outbreak of plague in Leith took place in 1645. Timber huts or 'ludges' were built on Leith Links to isolate those affected by the plague. Coffin makers could not keep up with the demand for their services, and many of the bodies were simply wrapped in coarse blankets and buried in communal graves. Several of these 'plague pits' have been discovered in Leith Links and nearby during excavation work.

The South Leith Parish Registers for the time give a contemporary insight into the plague and its effects. The first mention was in an entry dated 3 April 1645: 'Desyrs Jon Aldinstone to furnishe ye woman at ye yarde heads who is steekit up for feare of ye plague' and 'Desyrs Jon Kellas to furnish James Thomsone and Jon Dinlop till this day 8 dayes being inclosit for feare of ye plague.' Furnish in this instance meant to give provisions to, and the people referred to were in isolation.

Those who were ill were removed to the 'ludges' put up on Leith Links and their houses were cleansed and closed up. Infected clothing was boiled in large pots or cauldrons. An order was made that the town had to be cleaned in an attempt to stop the spread of the plague. On 1 July 1645 it was recommended that 'ane new burial place for ye deid in ye Linkes' be provided. By this time the plague had spread throughout the whole town, and was accompanied by famine. There were instructions for people to 'goeth along ye Ludges to have a care to see who are provydit in meat and drinks and who are not provydit and to report'. The plague eventually ended in November 1645 after a great storm washed the streets clean. At the end of this horrific outbreak of plague, it was stated that the dead in Leith outnumbered the living, with over 2,700 recorded deaths from a population of just over 4,000.

Q

The Quilts

The Quilts and Quilts Wynd are relatively modern streets. Developed in the early 1980s but with connections going back to the seventeenth century, this neighbourhood was where bowls, skittles and cachepell (real or royal tennis) were played. Quilts is a corruption of the French word 'quilles', which means 'skittles'. The name should apparently be pronounced with a hard 'k' sound as in 'quiche', which would make it sound like 'kilts'.

A game of quilles.

R

Rose's Lime Juice

Leith has been famous for centuries for its production of alcoholic drinks, but a very different well-known drink was also created there. In 1865 Lachlan Rose, the son of a Leith shipbuilder, founded L. Rose & Co., a business provisioning ships. Among these provisions was lime juice. The Merchant Shipping Act of 1867 required that every seagoing vessel had to carry lime juice as a protection against scurvy at a time when the carrying of fresh fruit and vegetables was not possible on long journeys. Incidentally, this daily ration of lime juice to sailors in the Royal Navy gave rise to the nickname 'limeys'. At the time lime juice was used solely for medicinal purposes and was generally preserved in rum, but Lachlan decided to make it more suitable for popular consumption. He sweetened the juice and put it in bottles, turning it into a new and attractive beverage, and so 'Rose's Lime Juice' with its distinctive bottle bearing the lime leaves and fruit emblem was born.

The firm's early years were spent in Mitchell Street and Constitution Street, with production from 1939 carried out at No. 2 Queen's Dock.

Royal Yacht *Britannia*

Leith has associations with shipbuilding and with royalty going back hundreds of years, so it is perhaps appropriate that the royal yacht *Britannia* is now berthed here. As a major tourist attraction, the royal yacht *Britannia* brings hundreds of thousands of visitors to Leith each year.

Britannia was launched from the John Brown & Co. shipyard in Clydebank on No. 16 April 1953 and, as well as being a royal residence for which the Queen and Prince Philip had input into the design, it was also built to become a hospital ship if needed. For over forty-four years *Britannia* served the royal family, during which time it travelled over 1 million miles.

In June 1994, the government announced that the costs of refitting *Britannia* were too great and that it would be decommissioned. The final journey took place on

20 October 1997, and all the clocks on board were stopped at 15.01, the time Queen Elizabeth stepped ashore for the last time.

Now *Britannia* is berthed permanently in Leith, where you can take a self-guided tour of the ship, including the Queen's Bedroom, State Dining Room and State Drawing Room, Sun Lounge, Sick Bay, and Engine Room. While on board, you can have refreshments or afternoon tea on the Royal Deck, which was formerly used by the royal family for games and entertaining.

Royal yacht *Britannia* berthed at Ocean Terminal.

Sailors' Home

The Sailors' Home was founded by Admiral Sir William Hall in 1853, and the present building on the Shore at the corner of Tower Place dates from 1885. The *Edinburgh Courant* of 10 June 1882 carried a front page notice appealing for contributions 'for this important benevolent object', listing the subscriptions already received and stating that the total amount required was £9,000. There were several subscriptions already received of £100 or £200, along with the handsome sum of £500 from the Leith, Hull and Hamburg Steam Packet Co.

The former Sailors' Home, now Malmaison Hotel.

Above: Angel above the main doorway, former Sailors' Home.

Right: Keeping a nautical theme in the reception, Malmaison Hotel.

The Sailors' Home was built on land which had been reclaimed from the sea with the construction of the Albert Dock in 1869. Special concrete foundations were required to build on 8 metres of sand. Facilities in the Sailors' Home included a restaurant for non-residents, a clothing store intended to supply garments at low market prices, a reading room, and recreation and dining rooms. Bathrooms had hot and cold water and flushing tanks. It had accommodation for fifty-six seamen and nine officers, and there were dormitories in the attics that could accommodate up to fifty shipwrecked seamen.

In the early 1970s, the building was used as a hostel by students attending Leith Nautical College, but by the late 1970s/early 1980s it had become the Angel Hotel, which had something of a dubious reputation as a haunt of 'ladies of the night', with the police being called out on a frequent basis.

Today the building still accommodates visitors to Leith, but in the very different form of the luxurious Malmaison Hotel which opened in 1994. The décor of the hotel pays subtle homage to the building's history, with some artistic nautical touches.

St Ninian's Manse

In 1493 a chapel to St Ninian was built on a site in Quayside Street. The building was extended and altered over the years, with a large church and manse being built in the 1600s. In 1606 it became North Leith Church, with its Dutch-style steeple being added in 1675. As the congregation grew, so did its need for larger premises, and it moved from Quayside Street to its current home in Madeira Street in 1816. The former church was sold to a local shipbuilder and was used for a time by other religious groups, then converted to a granary in 1825 and subsequently incorporated into McGregor & Co.'s Quayside Mills. St Ninian's Manse, now restored and converted for office use, is a

Below left: St Ninian's Manse with its Dutch-style steeple.

Below right: St Ninian's Manse, Quayside Street.

rare example of a seventeenth-century clergy building. From the 1930s it was used for processing animal feed, and was in a semi-derelict state when it was purchased by the Cockburn Conservation Trust in 1997, and the renovation of the building to offices was only made after thorough research including consulting the old church records and late nineteenth-century photographs and drawings. Examination of a panel from the belfry revealed the history of paint layers since its construction in around 1675. The weathercock is a reproduction of the original gilded copper one, which is held by the National Museum of Scotland.

Christian Salvesen & Co.

The history of the firm of Christian Salvesen goes back to 1851 when Salve Christian Fredrik Salvesen arrived in Leith from Norway to join his elder brother, Theodore, who was in partnership with a Leith merchant as shipping and forwarding agents, shipbrokers and timber merchants. After two years, Theodore transferred his interest in the partnership to Christian. The business continued to expand over the years, and in 1872 Christian left the partnership and set up Christian Salvesen & Co., based in Bernard Street, Leith.

His three sons, Tom, Fred and Theodore, joined the business during the 1880s, and the company built up a fleet of tramp steamers, started a cargo liner service between Scotland and Norway, and exported coal to Norway and the Mediterranean.

Theodore was on the lookout for a greater challenge than the import-export trade and looked to the whaling industry, which at the time was growing rapidly. In 1891 the firm purchased a stake in a whaling schooner but it was not until 1902 that they acquired a majority holding in an Icelandic whaling company. This only lasted a few years, but by then Salvesen had built up a significant whaling business, with ten whale catchers and stations in Iceland, Shetland and the Faroes. In 1907 they moved to the West Falklands then to South Georgia, where they named their base Leith Harbour. By 1910, Christian

Harpoon gun from a Salvesen whaling ship.

Salvesen & Co. was the largest whaling concern in the world, with whale oil, which was used for burning in lamps and for soap and glycerine, being their main product. The harpoon gun on display at the Shore came from one of their whale catchers. The firm suffered losses in both the First and Second World Wars, but were able to build up their fleet again. However, by the early 1950s the whaling boom was coming to an end and they wound down their operations, ceasing their involvement in whaling in 1963.

Christian Salvesen's whaling ships brought the first penguins back to Edinburgh in 1914 and donated them to Edinburgh Zoo, making it the first zoo in the world to house and breed penguins.

The Salvesen family built several memorial housing developments in Edinburgh, most on Scottish Veterans' Garden City principles, namely Earl Haig Gardens for injured and retired army personnel, Salvesen Gardens for army personnel and Salvesen Crescent for retired lighthouse keepers.

After the end of their whaling operations they diversified into many other businesses, and the company continues to operate successfully as a worldwide distribution and logistics company, but its historic links with shipping ended in 1990 when they sold all of their port and shipping operations. Their final link with Leith and Edinburgh ended in 1997 when their corporate headquarters moved to Northampton.

Christian Salvesen himself died in 1911 and is buried in Rosebank Cemetery in Pilrig Street.

Christian Salvesen's grave in Rosebank Cemetery, Pilrig Street.

Shipbuilding

Centuries of shipbuilding in Leith came to an end in 1984 when Henry Robb's, the last of the once many shipyards, closed.

The first record of a named shipwright in Leith was John Cornton in 1439. Before there were docks at Leith, it was only possible to build small craft of up to 100 tons. In 1720 the first dry dock in Scotland was opened at Leith, which made it possible to build bigger ships. One of the oldest shipbuilding firms was Sime and Rankin's, dating from the early eighteenth century. Ramage and Ferguson was another old firm that built steam yachts and sailing ships. They built the sailing ship *Kobenhavn*, which at the time was one of the largest sailing ships in the world. The *Kobenhavn* was a five-masted barque that was used as a naval training vessel, and was the subject of a great maritime mystery when she went missing at sea in December 1928 while travelling from Buenos Aires to Australia. Despite lengthy searches at the time, the ship was never found.

One of the most famous of the old firms was Menzies, who in 1837 built the *Sirius*, the first steamship to cross the Atlantic.

Close-up of section of mural depicting shipbuilding in North Junction Street.

HENRY ROBB LTD.
(Incorporating Ramage & Ferguson, Ltd.)

Shipbuilders, Repairers & Engineers

SPECIALISTS IN

High-class Passenger and Cargo Vessels, Tugs, Dredgers and all Types of Coastal and River Craft

NINE BUILDING BERTHS UP TO 420 FT.
FIVE DRY DOCKS UP TO 500 FT.

Victoria Shipyards, LEITH, Scotland

Telegrams: "Repairers, Leith" Telephone: Edinburgh 36881

Henry Robb newspaper advertisement from 1937.

Henry Robb Shipbuilders was set up in 1918, with the main activity at first being repair to war-damaged ships. From the 1920s, they began making dredgers, coasters and steamers, and in 1926 bought the adjacent Crane and Somerville yard. In the 1930s they bought over their main rivals, Ramage and Ferguson, who had gone into voluntary liquidation. During the Second World War they built many warships for the Royal Navy, then later went on to build passenger and cargo steamers. The firm became Robb Caledon in 1968 after merging with Caledon of Dundee. After being nationalised by the Labour government in 1977 and becoming part of 'British Shipbuilders', Robb's continued for a few years before running out of orders and closing in 1984 with the loss of several hundred jobs.

Signal Tower

The Signal Tower stands on the corner of the Shore and Tower Street. One of the oldest remaining buildings in Leith, it was built in 1685–86 by Robert Mylne. It was built of rubble and sandstone, and stood around 15 metres high. Its original purpose was as a rapeseed oil windmill.

At the end of the eighteenth century it was no longer functioned as a windmill, and was provided with windows, then the original domed roof and sails were removed, and the tower was topped by battlements.

In 1800, Captain Grindlay of Trinity House proposed a method of signalling from the tower based on various combinations of coloured flags denoting the depth of water on the sand bar at the entrance to the harbour. His system was improved by Captain Brodie in 1808 by using only one flag and two metal balls. Since this time the building has been known as the Signal Tower.

The seventeenth-century Signal Tower.

Smith & Bowman

The chemist and druggist Smith & Bowman was a familiar sight at the Foot of the Walk for many generations of Leithers. The original business there was founded in 1854 by Mr John Newbigging Smith. Some time later, after Mr Smith's death, John Bowman joined the business as manager and subsequently married Mr Smith's widow, the business then becoming Smith & Bowman. At one time there were several branches of Smith & Bowman, one being on Leith Walk at Crighton Place, and Bowman's son joined the business. John Bowman died in 1906, and in 1911 the business was taken over by Peter Nisbet and Mr A. Hamilton. The business continued to grow, and after Peter Nisbet's death in 1958 was run by his daughter, Winnie Nisbet, herself a qualified pharmacist who had worked there since the 1930s.

Above: Victorian chemist jars.

Left: Smith & Bowman's manager and staff outside the shop. (© A. Murray Wilson)

Particularly before the introduction of the National Health Service in 1948, many people would go directly to the pharmacist rather than pay the cost of being seen by a doctor. The pharmacist would give advice and make up medicines, and was no doubt privy to many secrets. It has to be remembered also that, before the advent of supermarkets, everyday items such as shampoo, soap and hairspray were generally only available from chemists.

In the 1960s, Smith & Bowman processed thousands of prescriptions every month, with the cost varying between being entirely free to 1s, depending on which government was ruling at the time. For each prescription made up by the pharmacist, the government paid out ½d (halfpenny). As well as NHS prescriptions, they also handled 'private prescriptions' which was in the 1960s the only means of obtaining oral contraceptives via a GP.

They were a stockist of perfumes and cosmetics, with salesmen bringing in samples of the latest items on a regular basis. These were always popular items, even though during the 1960s the 'luxury tax' on perfumes was as high as 58 per cent at one time. Some of the most popular cosmetic and toiletry brands were Max Factor (whose 'strawberry meringue' lipstick was a bestseller), Yardley and Coty. Lipstick sales always peaked when Russian sailors were in Leith, as they would buy large quantities to take back home with them.

The premises continue today as a pharmacy, now being part of the Lloyds Pharmacy chain.

South Leith Parish Church

The site where South Leith Parish Church stands, between the Kirkgate and Constitution Street, has a long and important history. It has been occupied since 1483 when the first church building, New Kirk of Our Lady, was built there. At this time there were several trade incorporations already formed in Leith – cordiners (shoemakers), fleshers, maltmen, tailors and merchants – all of whom would want to have their own altar and chapel in their parish church. The largest and by far the wealthiest group was the mariners, who considered themselves a fraternity rather than being incorporated, and it is likely that they first had the idea of constructing a church here and were joined by the other trades. Various altars and chapels within the kirk were endowed by both individuals and trades associations. The churchyard, like the church, was apportioned among the incorporations – maltmen, cordiners, hammermen, carters, porters, traffickers and merchants.

In 1544 when Leith was burned and looted on the orders of Henry VIII, the church was used as a refuge for the homeless. In 1547 Leith was again occupied by the English, the church was used as a prison for Scottish nobles, and everything of value in the church was either stolen or destroyed. When David Lindsay arrived as minister in 1560, he found a building that was bare of furnishings or decoration. Members of the congregation were free to bring their own stools to sit on, or could stand or walk about during the sermon and for many people it was a chance to catch up on news and gossip. The service would run from 8.30 a.m. to around 4 p.m., so it's of no surprise that a beadle had to walk around, carrying a staff, which he used to tap anyone who showed signs of nodding off! Women were banned from having their shawls or plaids over their heads, as this could hide the fact that they were actually asleep.

As a consequence of the Reformation, the form of worship at the church was changed in 1560 from Roman Catholic to Presbyterian.

South Leith Parish Church graveyard.

In an Act of Parliament of 1609, South Leith Church became the parish church of Leith, and in 1614 work finally took place to repair some of the damage caused in the previous century, with a new roof, bell tower and steeple being built. A few seats were starting to appear in the church, owning your own seat being something of a status symbol at the time. It should be remembered that at this time the church was not only responsible for the religious or spiritual wellbeing of its parishioners, but also for education and relief of the poor and the sick. In 1638 the kirk session issued badges to 'accredited' beggars, as they were troubled by beggars coming from Edinburgh and even across the water from Fife to beg in Leith.

During the occupation of Leith by Cromwell's troops in the 1650s, the church was used as a store for both artillery and horses. In 1674 the steeple was replaced, the new one being built by Robert Mylne, the king's master mason. This Dutch-style steeple remained until 1836.

The present church is to a large extent the work of architect Thomas Hamilton, who incorporated what was left of the old structure into the new church of 1848. In 1893

South Leith Parish Church, viewed from a window in Trinity House.

the layout of the church interior was altered and the church reopened in November of that year. From 1889 there was the first request to provide a stained-glass memorial window in the church, and this was followed by several such requests over the next few years, which was an indicator of the wealth that existed in Leith at the time, albeit alongside deep poverty.

The church is now a Category A-listed building and remains at the heart of the local community along with its halls nearby in Henderson Street.

State Cinema

The B-listed State Cinema in Great Junction Street has been allowed to fall into disrepair over the last few decades, although parts of the building are still in use.

When it was built in 1938, the art deco building was an innovative multi-use development of cinema, skittle alley, two billiard halls and four shops. The cinema originally seated an audience of 1,650, in seats which were described as being 'upholstered in jaspe moquette', with the auditorium being decorated in green, silver and ivory.

The former State Cinema on Great Junction Street.

The façade of the building was of artificial ashlar stonework, with the underside of the entrance canopy being surfaced with chromium to reflect the neon lighting. The entrance hall had walnut panelling, with its main features being the decorative columns and the pay box and confectionery stall, the fronts of which were made of wrought iron. The terrazzo floor had a modern design in orange and buff.

After the cinema closed in 1972, it became a bingo hall, and in 2002 was converted at great expense into the luxurious, but short-lived, Babylon nightclub.

In 2017, the building was sold to a property development company, who have put forward plans for a £5 million project to convert and extend it to form thirty-six apartments with underground car parking.

Sunshine on Leith

Sunshine on Leith, written by Stephen Greenhorn and first performed in 2007, is a stage musical built around the songs of The Proclaimers, which tells the story of two friends, Davy and Ally, who have returned to Edinburgh after serving in the army in Afghanistan, and their everyday struggles with family, jobs and relationships. The musical takes its name from The Proclaimers' second studio album, released in 1988, which included their hit song 'I'm Gonna Be (500 miles)'.

A film version was completed in 2013, with location scenes filmed in Edinburgh and Leith. While The Proclaimers (twins Charlie and Craig Reid) don't sing in the film, they do make a brief cameo appearance exiting a pub in Leith.

The song 'Sunshine on Leith' has now been adopted by supporters of Hibernian Football Club (Hibs) as a terrace anthem.

Incidentally, Leith had been known as 'Sunny Leith' long before The Proclaimers came along!

Advertisement for the stage musical *Sunshine on Leith*. (Reproduced by kind permission of West Yorkshire Playhouse)

T

Timber Bush

The street name of Timber Bush is a corruption of the French word 'bourse' meaning 'an exchange or meeting place for the transaction of business'. The name was first recorded in 1603 as Timber Burs, and then in 1698 as Timber Bourse. The exchange originally covered an area bounded by the Shore, Bernard Street and Tower Street and had its lower storey in the form of an open piazza. The Timber Bush was Edinburgh's official repository for the storage of wood imported into Leith.

It was reported that in 1644 the Leith timber trade had increased so greatly that the magistrates of Edinburgh ordered the area of the Bourse to be enclosed by a strong wall, from which time it became more permanent and important. The wall had the dual purpose of stopping the timber being washed away and preventing theft. Its proximity to the Shore made it easy for timber to be unloaded from ships and into the Bourse.

The Bourse itself is long gone, but the name lives on as Timber Bush.

Trinity House

Trinity House in the Kirkgate was built in 1816 on the site of a Seaman's Hospital dedicated to the Holy Trinity, which dated back to 1555. The basement of the original building survives under the present one, and two carved stones from the original are built into the exterior wall of the present building. In the seventeenth century the basement vaults were used as a schoolhouse, and when Cromwell's troops took possession of the building in 1650 they converted the vaults to an army store.

Trinity House was the base of the Incorporation of Mariners and Shipmasters for nearly 200 years, an Incorporation which was set up in the 1300s and collected port dues and provided aid to Leith's maritime community.

The building is now in the care of Historic Environment Scotland and is open to visitors by appointment. It has a very grand entrance and inner hall, with a magnificent staircase leading to the first floor. A war memorial window on the stairway was designed in 1933 to honour local merchant sailors who died in the First World War, and was rededicated in 1945 for those killed in the Second World War.

The nineteenth-century Trinity House.

Trinity House's war memorial widow.

The ground floor has the Master's Room, which has a fine collection of paintings of Leith, and the upper floor has the Convening Room, which has displays of objects connected with shipping, navigation and the whaling industry and a very fine ceiling, whose ornate plaster friezes also feature maritime subjects.

At one time Trinity House was surrounded by other buildings, but since the major redevelopment of the area in the 1960s it now stands in splendid isolation behind the New Kirkgate shopping centre.

U

Urban Regeneration

By the mid-1970s many parts of Leith had become very run-down. Shipyards, warehouses, cooperages and mills were vacant and unused. Much of the old tenement housing was considered to be no longer fit for purpose and occupants were being moved out to other parts of the city.

The first phase of the regeneration of Leith began in the early 1980s, when the conversion of old warehouses into housing started to take place, along with stone

Converted whisky bonds at Commercial Quay.

A–Z of Leith

cleaning and repair work to historic buildings. By the mid-1980s private developers were moving in and seeing the great potential of Leith. Wine bars and restaurants were opening up around the waterfront, replacing the pubs that had been frequented by sailors and dock workers.

By the 1990s more dockland was freed up and new developments containing offices, retail units and housing were appearing, along with private off-road car parking and more open spaces. A major development was the Scottish Executive building at Victoria Quay along with a new roadway called Ocean Drive. Close by Victoria Quay is Commercial Quay, a mixed-use redevelopment of warehouses and whisky bonds.

In the twenty-first century there appears to be no end in sight for development in Leith, with many new-build developments in gap sites and on reclaimed dockland.

There have been many concerns expressed about this 'gentrification' of Leith and its transformation into a tourist destination. The price of housing is beyond the means of many local people, and the old pubs and fish and chip shops they frequented and enjoyed have been replaced by expensive bars and Michelin-starred restaurants. There is a world of difference between the shops of Ocean Terminal and the Shore area and those of New Kirkgate and Great Junction Street, both in terms of price range and the types of goods sold. There have been some new developments of affordable and social

Modern flats at Ocean Way, overlooking Leith Docks.

Refurbished buildings at the Shore.

housing, but it's important that these aren't overtaken by expensive apartments, and that Leith remains a place with a range of housing that is affordable for all those who want to live here.

V

The Vaults

At the corner of Giles Street and St Anthony Street there is a large building called The Vaults or Vouts, once known as the 'Blak-Volts', dating mostly from 1682, but the extensive vaulted cellars may be much older, possibly from as early as 1587. The building was originally three storeys tall but was heightened to four storeys in 1785. The underground vaults comprise cellarage that was excavated in the natural sand,

The Vaults.

with a central vaulted passage and two vaulted cellars of around 21 metres long each. The Vaults is one of Scotland's oldest remaining commercial premises, which was originally used as a wine warehouse. It was owned for a long time by J. G. Thomson & Co., wine and spirit merchants, and is now the home of the Scotch Malt Whisky Society. Part of the building was converted to flats and offices in 1984.

Victoria Swing Bridge

After the opening of Albert Dock, a swing bridge became necessary to alleviate communication problems between the east and west sides of the harbour. The Victoria Swing Bridge, which was opened in 1874 at a cost of around £30,000, and constructed of wrought-iron mainbraced girders, carried a double rail and road track with a footpath along each side. At the time of building it was the largest swing bridge in the UK, and when open the large clear span allowed easy access for vessels navigating into the East and West Old Docks. It is a large single-span hydraulic swing bridge with a 36-metre span and an overall length of nearly 65 metres.

The bridge remained in use for vehicular traffic until the mid-1990s, when a modern road bridge was built close by. It was refurbished in 2000 with funding from

Victoria Swing Bridge from the Shore.

the Millennium Commission and Forth Ports PLC, which included renewal of the main timber deck and part of the timber resting platform at the east end, and was reopened by Lord Provost Eric Milligan on 22 November 2000.

Victoria Swing Bridge remains as an important and rare example of a nineteenth-century counter-weighted swing bridge.

Victoria Swing Bridge.

W

Irvine Welsh

Irvine Welsh was born in Leith in 1958 where his father was a dock worker, although the family moved to Muirhouse when he was a young boy. After leaving school at the age of sixteen and working in various jobs, he moved to London in the late 1970s, where he is reported to have become a heroin addict, and frequently got in trouble with the law, which eventually led him to turn his life around. He returned to Edinburgh in the late 1980s, where he worked for the city council and studied for an MBA at Heriot-Watt University.

During this time, Welsh started to write the short stories that would go on to become *Trainspotting*, which was published in 1993 and gained immediate fame for Welsh. The book was written in colloquial language, with much swearing, and depicted the darker side of life in Leith and Edinburgh. Reviews of the book ranged from acclamation to disgust, but the stage adaptation, which was premiered in 1994, went on to become a success, enabling Welsh to concentrate full time on writing from 1995.

The film adaptation of *Trainspotting* was released in 1996 to worldwide acclaim, and more bestselling books have followed, as well as screenplays and film directing.

Despite his huge success, Welsh is quoted as saying, 'Writing isn't a job, it's a hobby.'

Whisky Bonds

Leith had been a centre for storage of wine and brandy from the early sixteenth century, with as many as 100 bonded warehouses at its peak. At that time, wine and brandy were the premium drinks, with whisky being considered a poor man's drink.

Leith's bonded warehouse business dates back to 1822 when Leith was awarded one of six licences issued to ports in Scotland, which allowed them to store whisky under bond. Most of the warehouses changed to whisky storage in the late 1880s as a result of the collapse of the wine harvest in Europe.

From the 1850s, the expanding rail network and the various goods yards in Leith made the area perfect as a storage and blending centre. There were also, of course, related industries such as coopering and transporting. Leith became the home of many blenders, the most famous being William Sanderson & Sons, creators of VAT 69

Above left: Highland Queen newspaper advertisement from 1953.

Above right: VAT 69 newspaper advertisement from 1935.

whisky. The story of the name is that William Sanderson put together samples of almost 100 of his blends and invited experts to choose the best. The blend in VAT 69 was the unanimous choice, and William chose a bottle made in Leith for his new whisky. Crabbie & Co., most famous for their green ginger wine, also produced a range of malt and blended whiskies. Macdonald & Muir produced two brands associated with Leith – Baillie Nichol Jarvie and Highland Queen.

Even as recently as the 1960s, there were around 85 bonded warehouses in Leith, which together matured around 90 per cent of all Scotch whisky. The last bond closed in 1995 and most have now been converted into offices or housing.

Commercial Street former whisky bonds.

X

X-rated

Like most ports and dock areas, Leith has always had prostitutes to cater for the many sailors arriving there, and this certainly isn't a new phenomenon as these extracts from old records show.

The following extracts are from the records of South Leith Parish Church.

11 May 1649: 'Marion Wilsone and Beatrix Meason ... apprehendit be or searchers upo ye Lords day ye 6 of May 1649 in tyme of divine service coming out of ane English shippe and being both drunk were both put in prisone...'

7 March 1667: 'Marie Sinclare a debotch profane and wicked persone was ordained this day ... to remove out of this towne and paroch and never to be seen heir efter this day under the paine of scouring and publick banishment.'

16 July 1691: 'There are a great many scandals and much wickedness abounding in this parish...'

Turning to more recent times, from the early 1980s the city council allowed an unofficial tolerance zone for prostitutes close to the dock area, but as more residential property was built, residents complained and the prostitutes were moved a short distance away to an industrial area. However, as this area in its turn became more residential, there were again complaints and the tolerance zone came to an end.

While the docks area has now become pretty much cleaned up and gentrified, there was a time when a night out in Leith could really be wild. As well as the 'working girls' and go-go dancers, there was also Fairley's pub on the corner of Commercial Street where a black puma was kept in a cage in the lounge bar, and was occasionally let out on a leash.

Y

Yuletide Card

The first Christmas card is generally accepted to have been commissioned by Sir Henry Cole in 1843 and illustrated by John Callcott Horsley. However, this was preceded by the first Yuletide card, which was produced in Leith two years earlier by Charles Drummond, printer and publisher, using a drawing by his friend, Thomas Sturrock of Trinity. The card showed a smiling, chubby-cheeked boy with the greeting 'A Gude New Year and Mony o' Them' and was sold from Drummond's shop in the Kirkgate. So, Charles Drummond of Leith should rightfully get the credit (or the blame) for greeting cards being sent at the festive season.

Z

Zeppelin Air Raid

The first – and only – air attack on Edinburgh during the First World War took place shortly before midnight on 2 April 1916, when Edinburgh and Leith faced several zeppelin bombing raids. Apparently the Germans' mission had been to attack the naval base at Rosyth in Fife, and to then destroy the Forth Bridge. Instead, however, they targeted Leith Docks.

The docks were something of an obvious target, and there was considerable damage to boats, a grain warehouse, a whisky bond and several other buildings in the docks area. The blaze in the whisky bond lit up the sky for miles around, inadvertently lighting the bombers on their way. The cost of damage to the whisky bond was estimated at £44,000, a huge sum for that time.

There were some lucky escapes, where incendiary bombs fell on roofs and went straight through the top floor rooms into rooms below before exploding, but with no-one being injured. There was sadly loss of life in Commercial Street, where a man was killed as he lay in bed, and in Bonnington Road where an infant was killed.

Four incendiary bombs fell along the length of Mill Lane, adjacent to Leith Hospital. One struck the roof of the church manse, setting the building on fire and completely destroying it, although fortunately the minister, his wife and their servant all managed to escape. Another fell right outside Leith Hospital, and two more fell on Mill Lane, one in front of the school and another in the yard of a shipbuilder.

The Chief Constable of Leith had noted that the attack appeared to be following the course of the Water of Leith from Leith Docks to Edinburgh, as all of the bombs were dropped not more than 90 metres from the Water of Leith.

Acknowledgements

A huge thank you to all the organisations and individuals who have spoken to me about Leith and shared their memories and thoughts with me, both in person and online.

Special thanks go to the following: Morag Neil for providing the information on and photograph of Dean Owens (front cover photograph © Neilson Hubbard), Graeme McCormack for tales of Leith both past and present and for the use of his paintings of Malmaison (introduction page) and Down the Kirkgate (back cover), and Richard and Anna of Leith Theatre Trust for the tour of the theatre.

Thank you as always to my husband Tom for his proofreading, support and encouragement. I couldn't have done this without you.

Bibliography

The following books have been invaluable resources:
Boyd, David H. A., *Leith Hospital 1848–1988* (Edinburgh: Scottish Academic Press, 1990)
Grant, James, *Cassell's Old and New Edinburgh* (London: W. & R. Chambers Ltd, 1825, revised 1868)
Harris, Stuart, *The Place Names of Edinburgh* (Edinburgh: Gordon Wright Publishing, 1996)
Marshall, James S., *North Leith Parish Church – The First 500 years* (Edinburgh: Saint Andrew Press, 1993)
Marshall, James Scott, *The Church in the Midst* (Edinburgh: Edina Press Ltd, 1983)
Marshall, James Scott, *The Life and Times of Leith* (Edinburgh: John Donald Publishers, 1986)
Mowat, Sue, *The Port of Leith* (Edinburgh: John Donald Publishers, 1994)
Robertson, David, *South Leith Records* (Edinburgh: Andrew Elliot, 1911)
Wallace, Joyce M., *Traditions of Trinity and Leith* (Edinburgh: John Donald Publishers, 1997)

Stratford-upon-Avon
and Shakespeare's Country

*"This royal throne of kings,
 this scepter'd isle,
This earth of majesty,
 this seat of Mars,
This other Eden, demi-paradise"*

William Shakespeare
(Richard II)

Stratford-upon-Avon

Birthplace of England's greatest poet and playwright, the delightful old market town of Stratford-upon-Avon attracts many visitors. The town has been important since Roman times and its role as a market place continues to this day. Although best known for its associations with Shakespeare, Stratford, with its fine old buildings, broad streets and pleasant situation beside the tranquil River Avon, is an outstandingly beautiful country town in its own right. Situated in the heart of rural England, it is surrounded by historic towns such as Warwick, Worcester and Tewkesbury and is within easy reach of the beautiful Vale of Evesham, one of England's foremost fruit-growing areas. The northern Cotswolds with their tranquil villages built of honey-coloured stone, their sparkling streams and ancient churches would also have been well-known to the young William Shakespeare when he was growing up in the town in the 1560s and 1570s.

Flowing through the centre of the town, the River Avon was once an important trade route but today it is used mainly for leisure activities. Home of the Royal Shakespeare Company, the **Royal Shakespeare Theatre** rises impressively from the banks of the river in the heart of the town. Renowned for the outstanding quality of its productions, the theatre attracts audiences from all over the world. The first permanent memorial theatre was established in 1879, and in its first years it presented only ten days of Shakespeare Festival productions. Opened in 1932 to replace a previous building destroyed by fire six years earlier, the present theatre has a year-round programme of plays by Shakespeare and his contemporaries as well as modern works. Commissioned by local businessman Anthony Bird and sculpted by James Butler RA, the **Jester Statue** stands in Henley Street and was unveiled in 1994. It shows a jester holding two polls, or heads on sticks, which represent the masks of tragedy and comedy. The artist sees the jester symbolising the way in which "we dance through life finely balancing optimism above us, but tragedy lurks behind." Around the plinth there are quotations about jesters and fools taken from Shakespeare's plays.

Shakespeare's Birthplace, the fine half-timbered house in which William Shakespeare was born in 1564 stands in Henley Street. On his father's death in 1601, the property passed into Shakespeare's ownership and he in turn bequeathed it to his elder daughter. Now owned by the Shakespeare Memorial Trust and maintained as a permanent memorial to him, it is furnished in the style of the playwright's time and contains many items linked with his life. The garden features traditional varieties of fruit trees and bushes that were common in Shakespeare's time as well as many of the plants and flowers that are mentioned in his plays.

Anne Hathaway, Shakespeare's wife, was a farmer's daughter, and **Anne Hathaway's Cottage** continued to be a working farm for a further 300 years, remaining in the Hathaway family until 1892. Situated at Shottery just outside Stratford-upon-Avon, this picturesque 16th century yeoman's cottage is surrounded by a traditional English garden and an orchard planted with old varieties of apples and pears. The present vibrant cottage garden was created largely in Victorian times. Inside the cottage is preserved a fascinating collection of furniture from across three centuries, including the settle on which, according to tradition, the young Will Shakespeare sat when he was courting Anne.

The Elizabethan **Knot Garden** *(above)* provides an attractive area in the garden which is all that now remains of **New Place**, the house which Shakespeare owned for nineteen years. On his death in 1616 he left the house to his daughter Susanna, but it was eventually demolished in 1759. A peaceful oasis near the centre of Stratford, the **Great Garden** is a riot of colourful flower-beds and borders, enclosed in box and yew hedges. An ancient mulberry tree which shades the lawn is said to have been grown from a cutting of a tree planted by Shakespeare himself.

Adjacent to the garden stands **Nash's House** *(above)*. Once owned by Thomas Nash, who married the playwright's granddaughter, it now serves as a museum and contains many items of period furniture. The magnificent parlour *(left)*, with its ornately carved dining table, was originally two rooms and has a fireplace at each end.

Hall's Croft, once the home of Shakespeare's daughter Susanna and her husband, Dr. John Hall, stands in the oldest part of the town. One of the finest half-timbered, gabled houses in Stratford, it is now restored to look much as it did in the physician's time. In one of the upstairs rooms there is a fascinating exhibition containing relics of medical practice in the 17th century. Many of the herbs that Dr. Hall used in his remedies are still growing in the magnificent walled garden which also has some fine herbaceous borders of old English flowers.

The half-timbered **Grammar School** *(right)* which Shakespeare is believed to have attended, was founded in 1427. Beside it, at the corner of Chapel Lane and Church Street, is the **Guild Chapel**, originally founded in the 13th century, although rebuilt some two hundred years later. It was the chapel of the Guild of the Holy Cross, a medieval religious foundation which was abolished at the time of the Reformation, after which the buildings passed to the local corporation, along with the Guild's responsibilities for looking after the sick and maintaining the almshouses.

One of several fine buildings in the High Street, **Harvard House** *(left)* has a richly-carved frontage bearing the date of its construction, 1596, and the initials of Thomas and Anne Rogers, the original owners. The house, which contains some outstanding 16th and 17th century furniture, was later renamed after John Harvard, grandson of the first owners, who was responsible for founding the famous American university which bears his name. Patronised by leading actors and critics visiting the theatre, the **Shakespeare Hotel** *(below)* is a Grade 1 listed building and consists of two parts. The older, northern section dates from the early 16th century, although its four gables were built after the original façade was damaged during the Civil War. The southern section of the hotel, known as "The Five Gables", dates from the 17th century.

During Shakespeare's lifetime the superb, half-timbered **Falcon Inn** *(above)* was a private house, but it became an ale house in the 1640s and has held a continuous licence longer than any other hostelry in Stratford-upon-Avon.

In **Holy Trinity Church**, beside the tranquil River Avon, William Shakespeare was baptised in 1564, and here he, his wife and eldest daughter are buried. The church dates mainly from the 14th century, but the graceful spire was built in 1763 to replace the wooden one that Shakespeare would have known. The poet's gravestone can be seen in the chancel and nearby is a fine monument, erected within a few years of the poet's death.

The River Avon meets the Stratford Canal at the busy canal basin where colourful boats always create a lively scene. Between the river and the canal are the attractive **Bancroft Gardens**. Close to the town centre, they offer a delightful place to relax and watch the boats coming and going. Here stands the Commemorative Fountain which was erected to mark the 800th Anniversary of Stratford being granted a Market Charter by King Richard the Lionheart.

STRATFORD-UPON-AVON

On one side of the Bancroft Gardens stands the **Gower Memorial** *(right)*. Unveiled in 1888, it is crowned by a seated figure of Shakespeare, and around it there are statues of four of the great characters from his plays: Hamlet, Lady Macbeth, Falstaff and Henry V. Respectively they symbolise philosophy, tragedy, comedy and history.

The river is spanned by the splendid medieval **Clopton Bridge** *(bottom)*. It was built by Hugh Clopton, a Stratford merchant who was a great benefactor to the town and who, in 1492, also became Lord Mayor of London. The 14-arched stone bridge replaced an earlier timber structure and was the main river crossing at Stratford-upon-Avon for nearly four hundred years. The impressive Royal Shakespeare Theatre *(below)* dominates the north bank of the river.

Around Stratford

Adam Palmer's Farm, a fine example of a half-timbered Tudor farmhouse, stands in the little village of Wilmcote, north of Stratford. Built by Adam Palmer, a close friend of the Arden family, between 1569 and 1580, it is now maintained by the Shakespeare Birthplace Trust in the style of the period. Inside there is a large kitchen and dairy, and behind the house are farm buildings and a well-tended lawn.

Nearby is **Mary Arden's House** *(below)*, formerly known as Glebe Farm. This pleasing brick-and-timber farmhouse was the family home of Shakespeare's mother, and here she lived until her marriage to John Shakespeare, when the couple moved into Stratford-upon-Avon. Although some of the exterior walls were rebuilt in brick during the 18th century, much of the timber-framed structure survives and can be seen in the upstairs rooms. The **Shakespeare Countryside Museum**, housed in the old outbuildings, contains a working forge, a pigsty, a granary and exhibits relating to country crafts. Many rare breed farm animals, similar to those that would have been kept by the Ardens, can be seen on the working organic farm.

The construction of the Stratford Canal was authorised in 1795 to provide business interests in Stratford-upon-Avon with access to the newly developing canal network. It became a highly successful waterway in the first half of the 19th century but, like most canals, it suffered from competition with the railways and trade declined. The southern section, between Lapworth and Stratford, silted up and it was not until the 1960s that it was restored for recreational use. Climbing from the River Avon at Stratford through delightful wooded countryside, the canal reaches the small, scattered village of Preston Bagot where it is crossed by several bridges. An unusual feature of some of these is that they were built with a gap in the middle through which the tow-rope could be dropped.

Warwick and Royal Leamington Spa

The historic town of **Warwick** is dominated by its magnificent **Castle** which stands in a commanding situation overlooking the River Avon. The present structure dates from the 13th and 14th centuries and is surrounded by beautiful grounds landscaped by Capability Brown. Among many other notable buildings in the town is **Oken's House** *(below left)*, the 16th century home of a wealthy merchant who left his fortune to found almshouses in the town. **St. Mary's Church** *(below right)* is believed to date from pre-Norman times and by the 12th century it had similar status to a cathedral. Despite a disastrous fire in 1694, much of the medieval building survives.

WARWICK AND LEAMINGTON SPA

Jephson Gardens, bordering the north bank of the River Leam, is one of the most striking of the colourful and attractively laid out gardens which are a well-known feature of **Royal Leamington Spa**. An elegant town, with spacious terraces and squares of Georgian and early-Victorian houses, it was given the prefix "royal" by Queen Victoria. The bubbling mineral springs which brought fame to the town were first recorded as long ago as 1586, but it was not until the late 18th century that Leamington became a health resort.

The magnificent **Pump Room**, **Assembly Room** and **Public Baths** were all built in the early 1800s and by the middle of the 19th century Leamington had become a prosperous centre. Among Leamington's many fine architectural gems is the impressive **Town Hall** *(right)*. Standing in The Parade, it dates from 1884.

Around Kenilworth

Made famous in literature by Sir Walter Scott, Kenilworth Castle was an important fortress in the Middle Ages. The massive Norman keep, with walls up to twenty feet thick and a tower at each corner, is the oldest part of the castle. The gatehouse, and the towering apartments known as Leicester's Building, were added by Robert Dudley, Earl of Leicester, in preparation for a visit in 1575 by Queen Elizabeth I who stayed at the castle for nearly three weeks. The pageants and celebrations which were held in her honour are believed to have been seen by the young Shakespeare, and to have provided inspiration for his play *A Midsummer Night's Dream*. In existence for over 700 years, St. Nicholas Church was associated with Kenilworth Priory, later Abbey, which flourished from 1122 to its dissolution in 1538. The tower was added in the 14th century and the church owes much of its present appearance to additions and restoration undertaken in the 19th century.

Standing in isolation on high ground, Chesterton Mill dates from 1632 and continued working until 1910. This fine tower mill has an unusual construction, being built on arches and having a leaded, domed roof. The Grand Union Canal is lifted up out of the Avon valley by the formidable Hatton Flight. This comprises twenty-one closely spaced locks which raise the canal nearly 150 feet in less than a mile, providing superb views of the Warwickshire countryside.

Along the River Avon

Rising near Coventry, the Warwickshire Avon flows through Stratford-upon-Avon and on to Tewkesbury where it joins the River Severn. As the river winds from Evesham to Pershore, it passes a number of charming little villages including Cropthorne and Fladbury. Impressive **Cropthorne Mill** *(below)* stands on a little island between Fladbury Lock and the weir.

Situated about four miles from Stratford, **Welford-on-Avon** *(below)* is encircled in a loop of the river. A picturesque village with a green and a fine church reached through a lych-gate, it boasts a number of charming timber-framed, thatched cottages.

At nearby **Bidford-on-Avon** *(above)*, which appears to have changed little over the centuries, a fine 15th century bridge spans the river as it winds through the pastoral landscape. Local tradition suggests that Shakespeare walked from Stratford to Bidford with a group of friends to join in an ale-drinking contest at the Falcon Inn.

The delightful old town of **Evesham** has a wealth of historic buildings including the beautiful 14th century Abbey Almonry, the Tudor Round House and the 110 feet high Bell Tower *(below)*. Built in 1539 as part of the Benedictine abbey, the tower is flanked by 12th century All Saints' Church and the 16th century Church of St. Lawrence.

A little to the west of Evesham, is the little village of **Hampton**. Here the meandering River Avon, which is navigable at this point by small boats, can be crossed by means of an unusual hand-operated ferry.

Great and Little Comberton lie on the slopes of Bredon Hill and are among the most attractive villages of the Vale of Evesham. Each has an abundance of mellow timber-framed, thatched cottages surrounded by leafy lanes and overlooked by an ancient church.

The ancient market town of **Pershore**, with its spacious market square, received its original charter in 972 AD and is known for its 10th century abbey *(right)*. Part of the building was destroyed at the time of the Dissolution of the Monasteries under Henry VIII, but the fine abbey church has served as the parish church ever since. The town also has a splendid medieval bridge *(below)* spanning the River Avon.

South-east of Pershore, a ring of charming little villages is strung out across the beautiful Vale of Evesham, one of England's foremost fruit and vegetable growing areas. **Elmley Castle** *(above)* contains a wealth of picturesque thatched cottages and colourful cottage gardens which epitomise the traditions of rural England. Many of these have incorporated into their fabric, stones taken from the ruined Norman castle.

Bredon village, sheltered by the distinctive bulk of 960 feet high Bredon Hill, includes among its many interesting features a fine tithe barn *(above)* which dates from the 14th century. Built of beautiful Cotswold stone, it has a remarkable aisled interior. At nearby **Ashton-under-Hill** *(right)* the ancient cottages are grouped around an old stone cross.

The River Severn

The fascinating medieval town of **Tewkesbury** is superbly situated in a valley where the rivers Avon and Severn meet. Overlooking the town, the tower of the magnificent Abbey Church of St. Mary the Virgin *(below)* is the largest Norman tower still in existence, being 46 feet square and reaching a height of 148 feet. The church dates from 1121, and is all that remains of a once extensive Benedictine monastery. On Millbank, some picturesque riverside cottages and an ancient watermill *(right)* look out across the busy river.

Once a thriving port, **Upton-upon-Severn** *(below)* was also an important crossing point on the river and a busy staging post. Near the bridge stands the distinctive church tower. It dates from the 14th century, but because of the unusual cupola which was added in 1770 it is known as the "Pepperpot".

THE RIVER SEVERN

The city of **Worcester** stands on the River Severn and is dominated by its imposing cathedral. The original building was Norman but, although the crypt survives from this time, most of the present structure, including the magnificent tower, dates from the 14th century. This beautiful old city has a rich heritage of fine half-timbered medieval and Tudor buildings, several of which can be found in Friar Street. Among these is Greyfriars, built about 1480 as a hostelry for travellers, and the Tudor House, a 500-year-old timber-framed building which now contains a folk museum depicting life in the city through the centuries.

The Cotswolds

Famous for its tranquil villages nestling beneath the gentle slopes of the Cotswold Hills, this beautiful area gains much of its charm from the warm, honey-coloured limestone which was used alike for mansions, churches and humble cottages. **Broadway** *(below)* is deservedly one of the most famous of all Cotswold villages. It has an attractive, wide main street and many of the mellow stone houses and inns date from the 16th and 17th centuries when the art of Cotswold building was at its height. From Broadway Tower *(facing)*, a folly built in 1800 on a nearby hill, there are magnificent views in all directions which encompass not only the Cotswold Hills but also the Vale of Evesham, the distant ridge of the Malverns and the Forest of Dean. **Chipping Campden** *(above)* was a prosperous centre of the medieval wool trade and one of its most notable buildings is the Jacobean Market Hall, with its pointed gables and graceful arches, which dates from 1627.

On the northern edge of the Cotswolds surrounded by wooded countryside and winding lanes is the secluded hamlet of **Hidcote Bartrim** *(above)*. It has some delightful thatched cottages but is probably best known for the famous gardens at **Hidcote Manor** *(below)*. Created in the 20th century, they comprise a series of delightful small gardens each surrounded by walls or variegated hedges, and devoted to one species or colour combination.

Around Banbury

Banbury in Oxfordshire, with a fascinating history which dates back to Saxon times, is a charming mixture of the old and the new. It is perhaps best known for its Cross (*bottom*), made famous in the nursery rhyme *Ride a Cock Horse to Banbury Cross*. The original was destroyed in the 17th century by the Puritans and replaced by the present neo-Gothic structure in 1859 to commemorate the marriage of Queen Victoria's eldest daughter. The famous Banbury cakes, which consist of sugared puff pastry filled with dried fruits, are still made in the town. The Original Cake Shop (*below*) was built around 1550, but there is evidence of an earlier bakehouse which goes back to the 13th century, and it is thought that the recipe may have come into being when crusaders returned from the Near East bringing dried fruit and spices.

The **Oxford Canal** was completed in 1790 to link the Warwickshire coalfields with Banbury and Oxford. There are pleasant walks along the towpath from Cropredy Lock *(left)* which is situated just north of Banbury.

A superb example of a modest Tudor manor house and garden, **Sulgrave Manor** *(below)* was the ancestral home of George Washington, first President of the United States of America. His family emigrated to America after the defeat of Charles I by Cromwell. In 1914 the house, which is one of very few English country houses to fly the American flag, was presented to the people of Great Britain and the United States in celebration of one hundred years of peace between the two nations.

Stratford-upon-Avon

Key

1. RAILWAY STATION
2. SHAKESPEARE CENTRE
3. SHAKESPEARE'S BIRTHPLACE
4. TO MARY ARDEN'S HOUSE AND ADAM PALMER'S FARM
5. HARVARD HOUSE
6. GOWER MEMORIAL
7. ROYAL SHAKESPEARE THEATRE
8. BANCROFT GARDENS
9. TOWN HALL
10. SHAKESPEARE HOTEL
11. NASH'S HOUSE AND NEW PLACE GARDENS
12. GUILD CHAPEL
13. GRAMMAR SCHOOL
14. HALL'S CROFT
15. HOLY TRINITY CHURCH (SHAKESPEARE'S TOMB)
16. TO ANNE HATHAWAY'S COTTAGE